The Campus History Series

University of Louisville

Louisville

Belknap Campus

Go Cards!
Steve Bowen

Dave
Memory and
learning
Tom Owen

The Campus History Series

UNIVERSITY OF LOUISVILLE
BELKNAP CAMPUS

TOM OWEN AND SHERRI PAWSON

ARCADIA
PUBLISHING

Published by Arcadia Publishing
Charleston, South Carolina

Printed in the United States of America

Library of Congress Control Number: 2017941413

For all general information, please contact Arcadia Publishing:
Telephone 843-853-2070
Fax 843-853-0044
E-mail sales@arcadiapublishing.com
For customer service and orders:
Toll-Free 1-888-313-2665

Visit us on the Internet at www.arcadiapublishing.com

*For Phyllis and Jeff, for putting up with us during the writing
of this book and always.*

CONTENTS

ACKNOWLEDGMENTS

We are deeply appreciative to the University of Louisville's vice president for university advancement Keith Inman for his support and enthusiasm. Early on, the director of archives and special collections Carrie Daniels delighted in seeing our archival collections highlighted by this volume, and university libraries director Robert Fox made it clear he wanted the rich history of our campus revealed. Kenny Klein in athletics was a big help. Special thanks to our colleague Marcy Werner who scanned photographs without complaint. Jennifer Oberhausen and Renee Groulx helped track down just the right image and searched for obscure facts. Reilly, Delinda, Pam, Amy, Rachel, Heather, Kyna, and Sarah—the other members of our work family—provided research assistance, swapped desk shifts, and generally cheered us on.

Unless otherwise noted, all images appear courtesy of the University of Louisville Archives and Special Collections.

INTRODUCTION

The University of Louisville's Belknap Campus was a destination long before students filled its halls or visitors wandered its park-like setting. In the decade before the Civil War, the land was a city-owned cemetery where at least some burials occurred. Then, just as the guns of war sounded, the first building of a city orphanage and reform school—the Louisville House of Refuge—was ready for use, but before the institution could open, its campus was appropriated as part of a sprawling Union military complex.

In the post-war decades, the House of Refuge, renamed the Louisville Industrial School of Reform in 1886, evolved into a complex of at least 10 buildings. Following the merger of the city institution with its county equivalent in the early 1920s, the University of Louisville repurposed the old buildings for its central administration, College of Arts and Sciences, and a new engineering school.

This book chronicles the Belknap Campus story as it has unfolded over the past 90-plus years. Physically, the transformation has been striking, with new classrooms, dormitories, research facilities, and sports and recreational uses pushing far beyond that original reform school footprint and deep into adjacent residential and industrial neighborhoods. The World War II–era temporary barracks buildings are long gone, and the modern campus is a pleasant blend of old orphanage/reform school buildings (eight survive) and new construction. The scene is completed by a landscape peppered with water features, colorful plantings, outdoor sculptures, giant trees, and green spaces. A visitor who was last on campus in 1960 would barely recognize the place.

There have also been striking changes on the human level. For instance, black students were excluded from Belknap Campus until 1951, and since that time, racial tensions occasionally flared as the old order was challenged. Over the decades, the university made strides in making the campus more welcoming for all, regardless of sex, gender, class, physical limitation, or race. Further, starting in the 1950s, a revolution occurred in policies related to personal freedom; looking back, it is hard to believe that women students could not wear shorts or slacks to class and were subject to stringent dormitory curfews. On the other hand, until the late 1960s, a classroom filled with cigarette smoke was considered normal.

A campus is an incubator of enduring memories where perceptions are deepened, collective wisdom analyzed and evaluated, and the unknown probed. For many, it was on Belknap Campus where, in the blossom of late adolescence, a student first attended a protest demonstration, became hoarse rooting for a Cardinal team, or was immersed in student government, Greek life, intramurals, or just hanging out. For others who commuted frenetically to campus

while juggling career and family, the sharpest memory might be the interminable wait in the registration or bookstore line or the continuous search for an empty parking space.

Finally, memories of human interactions fuel our keenest college recollections. We recall the advisor who patiently set us on a solid path, the counselor who helped us figure out a way to pay our tuition, the researcher who explained a plan for probing the complex systems that are at the heart of things, or the dorm mate who regaled us with tales of a life that was so different than ours. At UofL, curators unwrapped timeless artifacts and documents, professors vividly laid out the art and architecture of the ages, and scholarly sages articulated the accumulated wisdom of the past in compelling ways. For many, there are memories of things taught that make so much sense that they still provide guidance for our lives.

Despite its rigors, the academy provides time to indulge in the special power of language to persuade, entertain, and cajole. University days are necessarily an interlude, a time of preparation before the full weight of certification and accountability set in. Ultimately, the greatest gift that days on Belknap Campus can give is a lifetime of amazement at what it means to be human and a stubborn commitment to be guided by our most humane light.

We hope these pictures and snippets of the history of the University of Louisville's Belknap Campus provoke warm recollections, inspire commitment to the unfinished pursuit of fairness and justice, and deepen appreciation for the current work of a venerable institution that has opened doors of opportunity for so many. Go Cards!

One

HOUSE OF REFUGE

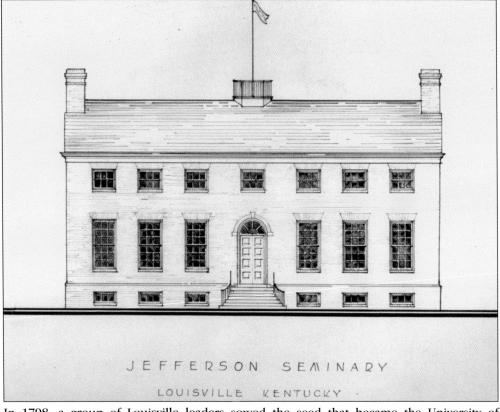

In 1798, a group of Louisville leaders sowed the seed that became the University of Louisville by chartering the Jefferson Seminary. The school, with its classical (not sectarian) curriculum, actually opened in 1813 and closed in 1829, but some eight years later, residual seminary assets were used to establish a direct predecessor of the University of Louisville. That connection to the Jefferson Seminary charter enables the university to use 1798 as its founding date, a claim recognized each year on diplomas and commencement programs.

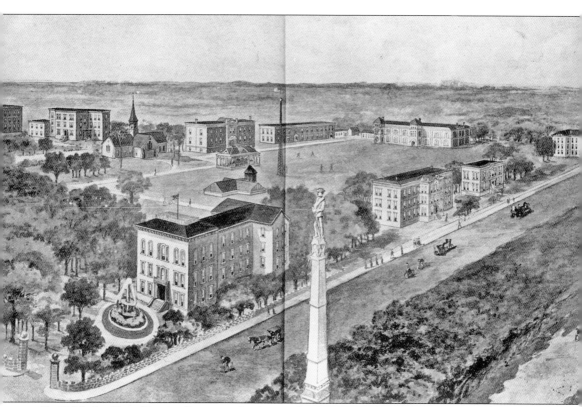

In 1854, the City of Louisville granted a charter for the establishment of a home for orphaned and delinquent children. Located on the site of the defunct Southern Cemetery, the Louisville House of Refuge, renamed the Louisville Industrial School of Reform in 1886, served children and youth until 1925, when the University of Louisville moved to the site. The orphanage/reform school merged with a similar county institution at Ormsby Village. Gardiner, Gottschalk, Ford, Jouett, and Patterson Halls were dormitories for the old facility, while Oppenheimer and Brigman Halls housed classrooms and shops for carpentry, metalwork, and other industrial skills. The Protestant chapel is known today as the Playhouse, though it was moved in the late 1970s from its original House of Refuge location to its current home to make room for the Ekstrom Library.

The Playhouse was constructed in 1874, making it the second oldest of the orphanage/reform school buildings to survive for university use. Built in board and batten/Carpenter Gothic style, complete with a steeple, the structure served as the Protestant chapel for religious services and convocations for the young wards. After acquiring the site, the university quickly adapted the old church as a venue for decades of great student and community theater performances. The Playhouse windows are a telltale giveaway that the theater once was a place of worship.

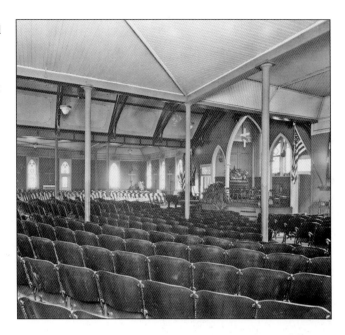

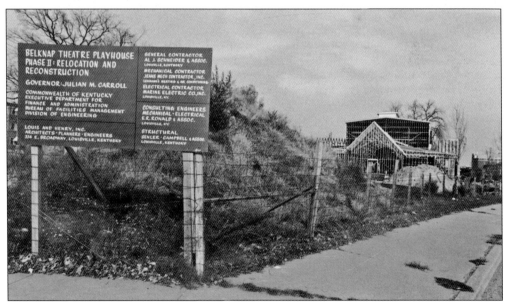

In 1976, the University of Louisville announced demolition plans for the Playhouse to make room for the new Ekstrom Library. After a preservationist outcry that led to the listing of Belknap Campus in the National Register of Historic Places, Gov. Julian Carroll stepped in with a relocation site and funds to assist the move. In 1977, the unique Playhouse was taken apart board by board, stored in a warehouse for several years, and reconstructed on a traffic island at the corner of Third Street and Cardinal Boulevard (old Avery Street).

On arrival to the new campus in 1925, the newly formed Speed Scientific School (now Speed School of Engineering) opened in what had been the old industrial school's 1893 manual arts training building. Bennett M. Brigman, a former arts and sciences faculty member, provided critical early leadership as engineering's first dean. Despite starting a move south of Eastern Parkway in 1941, the engineering school continued to use its early home, which was named Brigman Hall in 1949, until 1958. The well-worn structure then housed the School of Business from 1958 to 1974 and, later, the School of Police Administration.

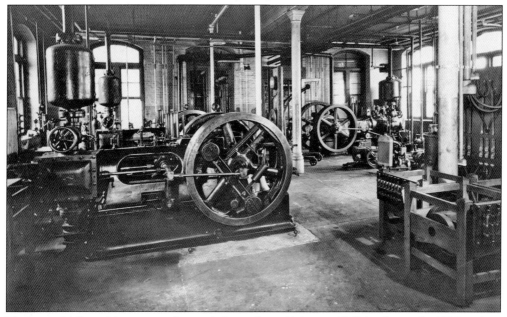

The sound of machinery reverberated throughout Brigman Hall in the early 1890s when orphan and delinquent children were taught manual skills like leather and woodworking. After 1925, machine noise continued when mechanical engineering students practiced operating heavy industrial equipment.

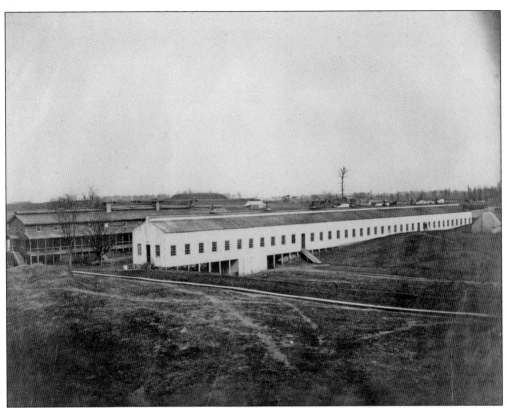

In 1861, the very year the Civil War began, the first building for the orphanage and reform school was built, but before the young wards could move in, the whole site was acquired for Park Barracks, part of a larger Union military complex that included a defensive fort and the Brown General Military Hospital (pictured). Officers and men bivouacked on the reform school campus had easy access to the hospital located up the hill toward present-day Interstate 65, just beyond the Warnock Street McDonald's restaurant.

When the university came to campus, Ford Hall, a women's dormitory for the orphanage, became the Home Economics Building. For several years in the mid-1940s, a faculty/staff cafeteria operated on the lower level. In 1982, the building was named for A.Y. Ford, the university's first full-time, salaried president, who served from 1914 to 1926. Ford Hall is home to the political science department.

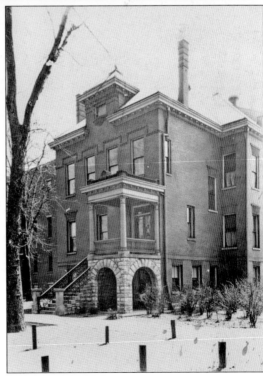

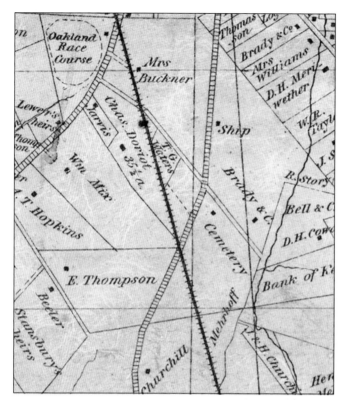

In 1851, the City of Louisville purchased 82 acres in Louisville's near-countryside for its Southern Cemetery, later called Oakland Cemetery. A residence for the sexton was built, and there is strong evidence that, at least by 1854, burials had occurred. Late in the decade, the city closed the cemetery and conveyed the property to the House of Refuge. The transfer agreement specified that all bodies buried on the site had to be disinterred and reburied in Cave Hill Cemetery.

By World War I, the college had outgrown its quarters at the Silas Miller mansion on West Broadway when the family of recently deceased Louisville hardware magnate William R. Belknap donated a 70-acre farm in the Highlands neighborhood near Douglass Loop. In anticipation of imminent construction, students who held picnics on the farm called it "Belknap Campus." When a 1923 city bond issue to help fund new campus construction failed, the suburban property was sold for a subdivision called University Park (with street names like Harvard, Princeton, Yale, and Sewanee); the proceeds were used to buy the House of Refuge site. In 1927, the university's new home was formally named Belknap Campus, with the entrance columns flanking the oval drive to the administration building named the William R. Belknap Gates.

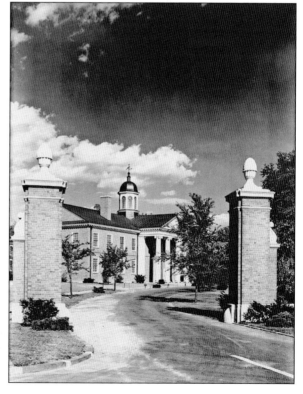

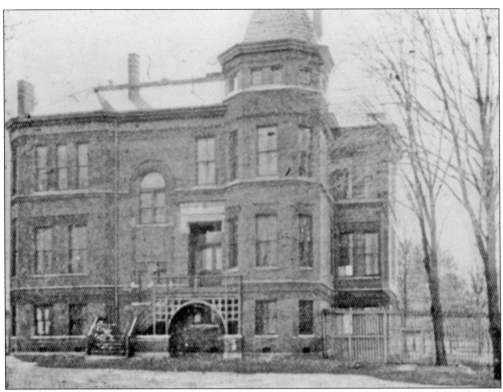

Gottschalk Hall was built in 1894 as a dormitory for young African American women housed at the orphanage and was originally named for Charles D. Jacob, a popular late 19th century four-term mayor. When the university arrived, the old dormitory was converted into the Chemistry Building, removing an unusual wooden stairway that entered at the second level where a window is now. (In 1947, a one-story, frame World War II structure from Bowman Field was moved to the rear of the building and used well into the 1970s as the Chemistry Annex.) In 1954, the Chemistry Building became the Social Science Building, and in 1975 was renamed for distinguished University of Chicago historian Louis Gottschalk, who had a brief but controversial tenure at the university in the late 1920s. The history department is housed there now.

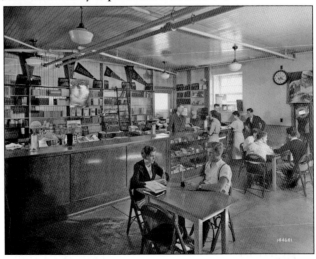

In 1935, the campus bookstore in the basement of Gardiner Hall was enlarged to include a snack bar. The *Louisville Cardinal* student newspaper celebrated the fact that at last hot food was available on campus. An adjoining room was outfitted for quiet gatherings of students. Slowly, Belknap Campus was acquiring those services that would make it attractive to prospective students.

Gardiner Hall is the oldest of the old city reform school buildings surviving on Belknap Campus. The imposing structure—shaped like a cross—was built in 1872 to house the female department (dormitory). The words "Liberal Arts" were inscribed on the facade of the building that was first adapted for classroom use and later for the arts and sciences dean's office. University donor Clarence R. Gardiner, who died just as University of Louisville was preparing to open its new campus, is honored in the building name. The stone water fountain (below, at left), which has since been removed, was given by the class of 1936. Behind it, a portion of the former Dean's Building, demolished in 1975, is visible.

Two

GROWTH

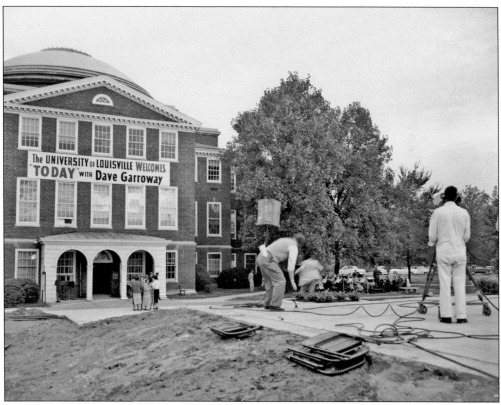

NBC Television's *Today Show* brought host Dave Garroway and crew to Louisville for the Kentucky State Fair on September 10 and 11, 1956. The national telecast stopped on campus the first day, where the new library was visited, members of the men's basketball team were interviewed, and a style show featuring eight students was presented. The Louisville Orchestra and the University of Louisville Brass Quintet also performed.

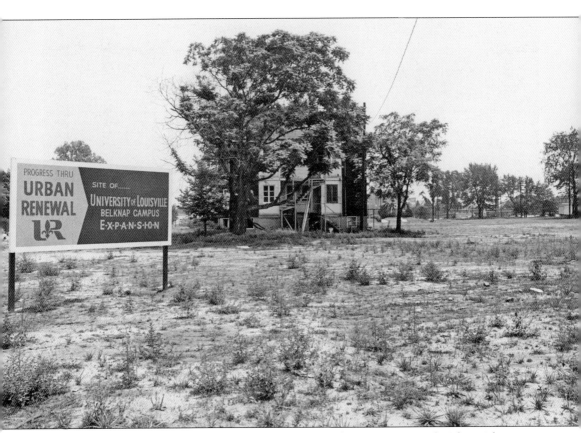

PROGRESS THRU
URBAN
RENEWAL
UR

SITE OF......
UNIVERSITY OF LOUISVILLE
BELKNAP CAMPUS
E·X·P·A·N·S·I·O·N

Beginning in the early 1960s, the federal Urban Renewal program assisted with rapid campus expansion northward into a well-established neighborhood of commercial buildings, churches, scores of residences, and an industrial zone on either side of a rail corridor that borders on the east flank toward Interstate 65. Several structures in the urban renewal area including the Houchens Building (an industrial warehouse on Brook Street) and the Overseers Building (a residence on old First Street) were retained for university use. For a decade or so though, it was not unusual to see a new university building rise up right next to a neighborhood structure waiting for demolition.

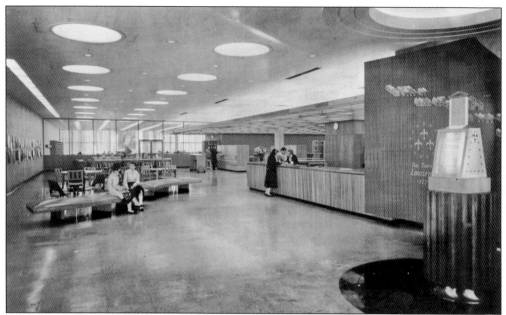

An ultra-modern library boasting blond wood furnishings, a large colored-glass Minerva (the university's symbol) on the north face, and plenty of openness to the outside was dedicated in 1957. A dome-shaped light brightened the airy entrance where Louisville's 1780 charter was displayed on an elaborate artist-designed pedestal that stood in front of a stylized inlaid wood mural of a 1779 Louisville map. The mural now hangs in Ekstrom Library, while the charter is in the care of the university archivist.

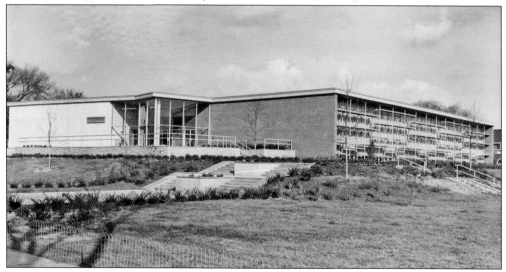

In 1978, the library was named for veteran head librarian Evelyn Schneider, who retired in 1965. The building now houses the fine arts department including classroom, studio, library, and gallery space. Slate porches and landings with stone retaining walls lined the west and south sides of the library. Over the decades, those walls have served as gathering places for impromptu outdoor classes. Though Belknap Campus is universally flat, Schneider Hall's front entry is designed to create the impression that the building sits at the top of a small rise.

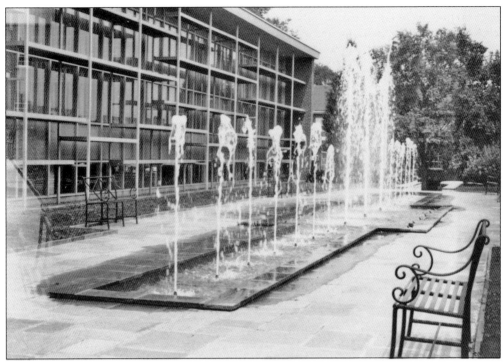

In 1964, when the library was just eight years old, local industrialist and UofL trustee Archibald P. Cochran donated a lovely fountain as a memorial to his parents that defines the entire south face of Schneider Hall. The Cochran Fountain, set in abundant landscaping and replete with murmuring water jets and a lighted reflecting pool, remains one of the campus sweet spots. From time to time, the fountain basin has overflowed with suds after pranksters seeded it with laundry detergent.

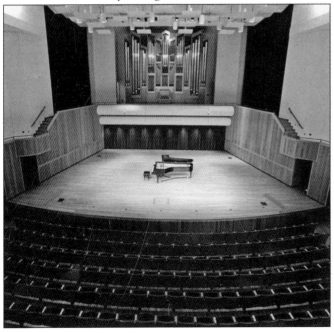

The 1932 School of Music was first led by Julliard-trained dean Jacques Jolas, and included faculty from the defunct Louisville Conservatory of Music. Later, in the 1930s, the school enjoyed steady leadership for over 20 years under dean Dwight Anderson. Famed Louisville Orchestra conductor Robert Whitney also served as dean from 1956 to 1971. In 1980, a new building was completed, housing the Dwight D. Anderson Library and a 558-seat performance venue, the Margaret Comstock Concert Hall.

The 1980 College of Education and Human Development (CEHD) building was named posthumously for Woodford and Harriett Porter in 2010. Woodford operated a prominent local funeral home, was the first African American member of the Louisville Board of Education, and served as a university trustee for 24 years, including four terms as chair. Harriett was a graduate of Louisville Municipal College, worked as a public school educator, and served as a community volunteer. Earlier, CEHD (which became a separate school in 1968) was largely housed in Oppenheimer Hall.

A new library required the relocation of the Playhouse (the old reform school's Protestant chapel) and the removal of two smaller buildings. The library opened in 1981 and is named for William F. Ekstrom, a beloved English professor who started at the University of Louisville in 1947 and served two stints as acting president.

21

In 2006, a substantial west wing was added to the Ekstrom Library, made possible by a federal earmark sponsored by US senator from Kentucky Addison Mitchell "Mitch" McConnell, a 1964 graduate. The historic tulip tree, deemed unhealthy by arborists, was removed for the addition, but for many years, the coffee shop in the new wing bore the "Tulip Tree" name. Ekstrom's west wing includes the McConnell Center for Political Leadership, which had begun in Ford Hall in 1991; the Elaine Chao Auditorium; and a multistory Robotic Retrieval System designed for the storage and retrieval of up to 1.2 million volumes. In 2009, the Mitch McConnell and Elaine Chao Archives was opened in the lower level. Below, undergraduate Mitch McConnell is pictured at center, with Frank Howe on his right, along with three unidentified students.)

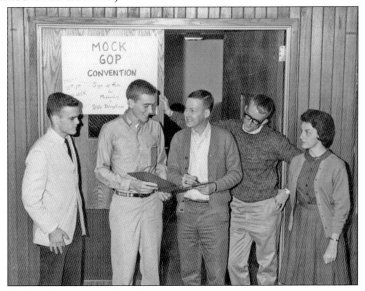

The Student Activities Center (SAC) was uniquely designed with crash walls and safety glass to withstand the impact of a train derailment, and features a pedway that spans the railroad track that divides the two halves of the building. The student center opened in 1990, and featured a movie theater, Cardinal Arena (home court for women's volleyball), athletics office space and ticket center, student organization offices, and plenty of eateries. Four years later, a carillon/clock tower was dedicated, and in 1999, the SAC (currently undergoing significant renovation) was named for the University of Louisville's 15th president, Donald Swain, and his wife, Lavinia. Harold Adams Way, the elevated west pedestrian approach to the building's second level, is named for the popular assistant vice president for student life.

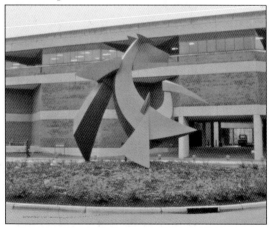

Big Red, a sweeping three-ton sculpture installed in 1989, stands at the center of Jane Goldstein Plaza in front of the College of Business. The 1985 building was named in 2011 for real estate magnate Harry S. Frazier. Also, in 2011, an addition that houses both the Marion and Terry Forcht Center for Entrepreneurship and the Equine Industry Center was completed. In 2012, the plaza honoring Goldstein, a longtime assistant dean at the college, was dedicated.

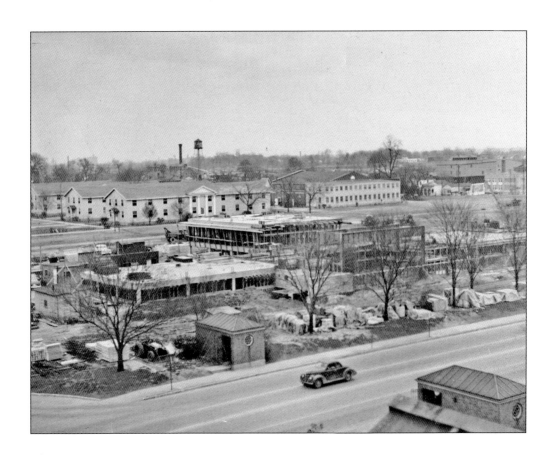

In 1941, when the Speed Scientific School moved south of Eastern Parkway from Brigman Hall, a tunnel was dug under the roadway to improve pedestrian safety. At first, the tunnel entrances on each side were largely enclosed, as seen above (note the construction of the Natural Sciences Building), but later they were opened to make the dank and sometimes smelly passageway airier and more welcoming. In 2010, the tunnel openings were capped and Eastern Parkway was dramatically redesigned with handsome landscaping and fencing to encourage safer crossing at the signalized intersection. (Below, courtesy of Clyde Paul.)

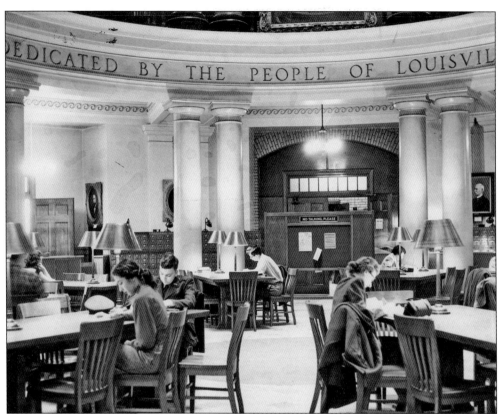

For almost three decades, central administration shared Grawemeyer Hall with the library and others. Just seven years after its 1927 opening, the building's signature rotunda had to be enclosed at the second level to make room for a growing library, while the circular room below housed the registrar and bursar's offices. The rotunda was not restored until 1975.

The 1927 Administration Building, the first building constructed after arriving on campus, was renamed in 1988 for a Speed engineering graduate and local industrialist, Charles Grawemeyer. Its Georgian-revival architecture was inspired by Thomas Jefferson's early 19-century Rotunda at the University of Virginia. This holiday photograph predates 1949, when Rodin's early 20th-century *The Thinker*, a gift to the city by a local community leader, was placed here.

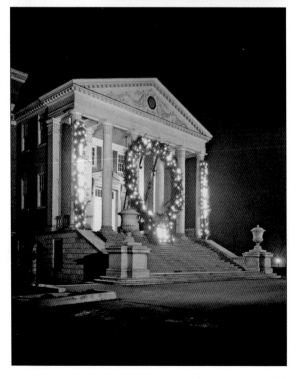

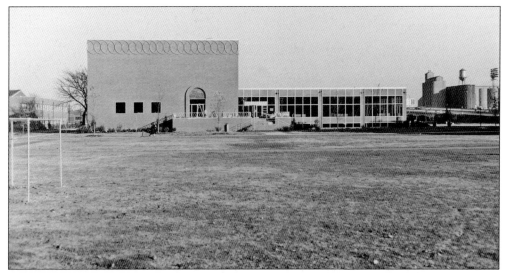

In 1959, the university cut the ribbon on a long-needed multipurpose student center located just south of the new library (Schneider Hall), which had opened two years earlier. It quickly became known as the "hula hoop building" because of the 198 interlinking aluminum circles that decorate both its block tower and porch and balcony railings. In 1991, the computer center moved in, and four years later, the building was renamed the Miller Information Technology Center, honoring the University of Louisville's 14th president, James G. Miller, who served from 1973 to 1980, and his wife, Jessie.

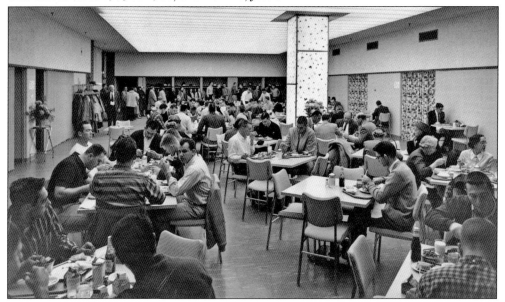

University College (old Division of Adult Education), responsible for night and professional development classes, occupied a "front door" location in the new student center's three-story tower. Conference rooms and the audio-visual department (including television) were located above. Throughout the building, there were plenty of places to eat (the cafeteria is pictured), a bookstore and game room, campus radio station, student government and yearbook offices, and over time, the dean of students and other student services. Bigelow Hall, a multipurpose auditorium with 380 moveable chairs, is located on the first floor.

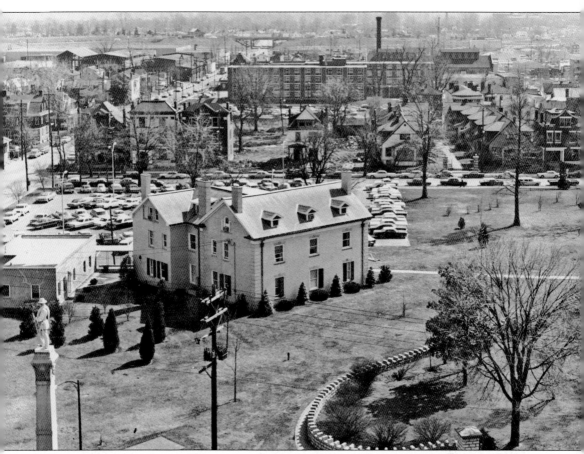

Robbins Hall was a yellow brick residence built in 1927 so that benefactor Hattie Bishop Speed could live near her beloved Speed Museum. When she died, the university was given the home with a proviso that the donor's niece, Jennie Robbins, could reside there until her death. Robbins Hall was converted in 1946 into the first dormitory for women (with 30 beds), a use that continued into the late 1950s. Then, the Kent School of Social Work was housed there from 1962 to 1975, and until demolition in 2011 for a museum expansion, occupants included the Life Planning/Placement Office, Disability Resource Center, and Interpreter Training Program. This 1960s photograph shows how Belknap Campus edged northward into a largely residential neighborhood. The top of the Confederate Monument is visible in the left foreground, Brandeis Avenue is at left center, and Second Street runs across the photograph at center. Miller Hall appears toward the rear, and the Caldwell Tank Company, from which the Red Barn was salvaged, can be seen in the distance.

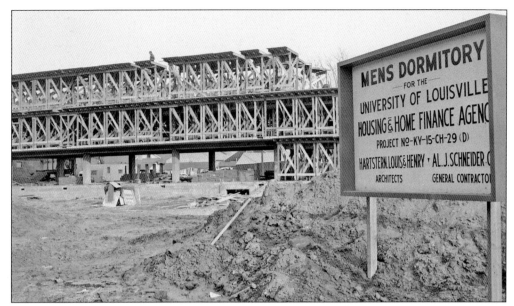

In a short span between 1959 and 1966, the first modern dormitories were constructed: Stevenson, Threlkeld, and Miller Halls (in that order), across Shipp Street on the east side of former First Street, though Threlkeld Hall does sit back a good bit. The building names honor long-standing graduate school dean and mathematics professor Guy Stevenson, dean of women and education professor Hilda Threlkeld, and bank president and trustee chair Lee P. Miller.

The Humanities Building, completed in 1974, was constructed with brick and concrete block panels. It contains classrooms, two lecture halls, labs, and offices, and on November 5, 1979, was named for Barry and Mary Bingham. The Bingham family owned a local media company, including the *Courier-Journal*, and were well known arts enthusiasts and university benefactors.

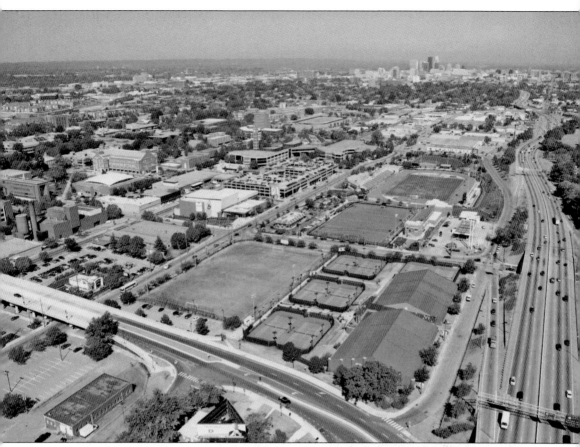

Since 2000, Owsley Brown Frazier Cardinal Park has become the dramatic front lawn for Belknap Campus's eastern face along Interstate 65. The string of premier athletics fields, anchored in one corner by a McDonald's, spreads across several city blocks of what was once sprawling gravel parking lots and a few offices. Cardinal Park houses the Dan Ulmer Softball Stadium and the Trager Field Hockey Stadium, both testimony to the university's strong commitment to women's athletics. The Trager complex includes the Marshall Center, a strength and conditioning facility for all Olympic sports that features 8,000 square feet dedicated to weight, strength, and cardio training. In addition, there is a track and field stadium boasting a nine-lane running track and the Don Fightmaster Playground for Exceptional Children. The Bass-Rudd Tennis Center, a soccer practice field, and the Ralph Wright Natatorium (visible just north of Eastern Parkway in the foreground) are adjacent to Cardinal Park.

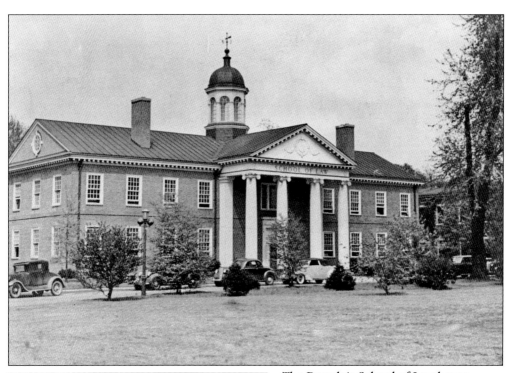

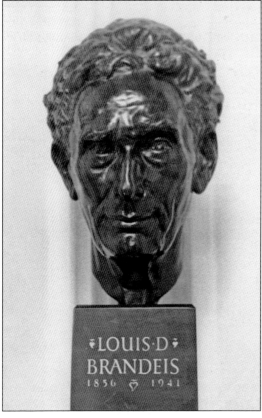

LOUIS·D·
BRANDEIS
1856 1941

The Brandeis School of Law began in 1846 and was housed in several downtown locations. In 1938, aided by matching funds from the Works Progress Administration, the university built a Belknap Campus home for law on the oval. The next year, Louis Dembitz Brandeis, a Louisville native and Boston attorney appointed as the first Jewish member of the US Supreme Court in 1916, retired but continued donating research collections, including his personal papers, to the school. The cremated remains of the justice and his wife, Alice, are buried under the front portico of the law school. The building was named in 1997 for Louisville mayor, lieutenant governor, and civic leader Wilson Wyatt, an alumnus of the Jefferson School of Law, which was absorbed by UofL in 1950. Also in 1997, UofL named its law school for Louis D. Brandeis.

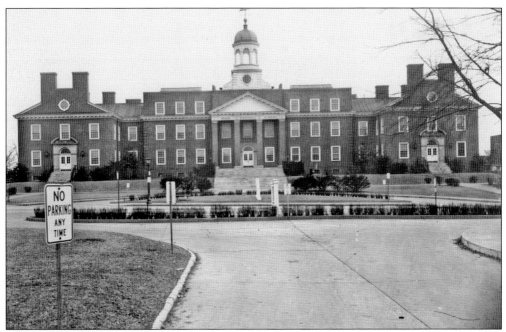

In 1941, the Speed Scientific School (renamed the Speed School of Engineering in 2003) made the move across Eastern Parkway with the construction of James Breckenridge Speed Hall, honoring a Louisville industrialist. Speed's two children, William S. Speed and Olive Speed Sackett, had provided funds to launch the engineering school in 1925; in 1940, they provided the money in a two-to-one match with the Works Progress Administration to construct Speed Hall.

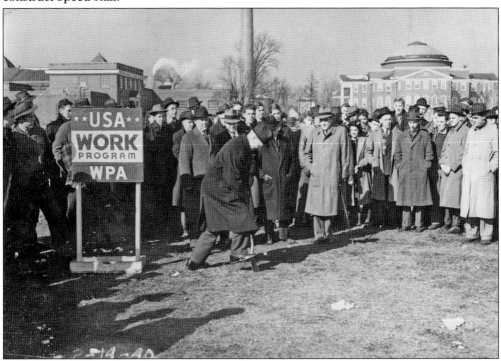

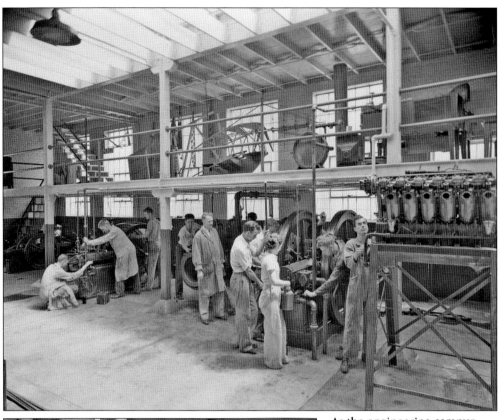

As the engineering campus developed, two additional buildings acknowledge the financial contributions of the two Speed siblings: William S. Speed Hall, named for the brother, and Frederic Sackett Hall, honoring sister Olive's husband who served as US senator from Kentucky and US ambassador to Germany. Additional buildings recognize Robert C. Ernst, longtime dean of the school; Henry Vogt, an early 20th-century industrialist; and university donors George and Mary Lee Duthie. Margaret Mattingly (shown above on the shop floor in 1936) became the first female graduate the next year. Today, the Speed School of Engineering works to attract and support women and other under-represented groups of students.

The northern sector of campus still had a transitional feel when Davidson (above) and Strickler (entry shown below) Halls were built in the early 1970s in response to enrollment growth spurred by state affiliation. Financed with state funds, the buildings were constructed between First and Second Streets and named in 1975 for Philip Davidson, the University of Louisville's 12th president (1951–1968), and his successor, Woodrow "Woody" Strickler (1968–1972). Jane Davidson and Florence Strickler's names were added to the building two decades later in recognition of the contribution to the life of the university by those presidents' wives.

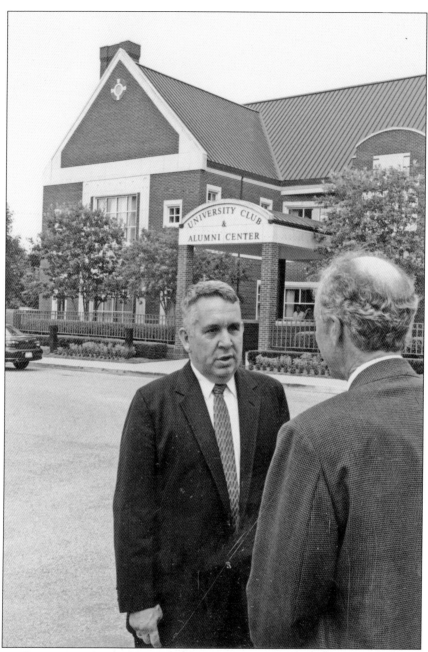

Rodney Williams earned a bachelor's degree in 1965 and a law degree from UofL in 1968. He became director of alumni services in 1977, a position he held until 1996. Here, Williams is seen facing longtime director of university archives William Morison outside the alumni club. The "U Club," constructed to resemble an English country inn, opened as a social and dining destination for faculty, staff, and alumni in 1990. The club offers casual and formal dining, a reception area, a pub, a library, and a ballroom. Upstairs is home to the alumni center offices, board room, and reception space. In 2004, the building was named the Malcom Chancey Jr. University Club and Alumni Center to honor the alumnus, board of trustee member, and longtime benefactor.

Three

SPECIAL EFFORTS

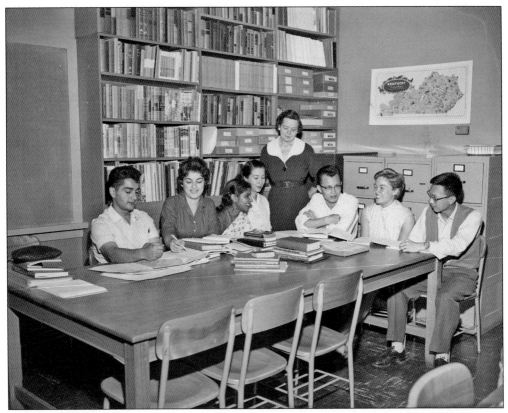

Prof. Meta Riley Emberger is pictured with international students in the English lab workshop in 1960. The non-credit summer program was open to high school juniors and seniors to improve their knowledge and comprehension of basic English. Over the years, life on Belknap Campus has been enormously enriched by students from across the globe.

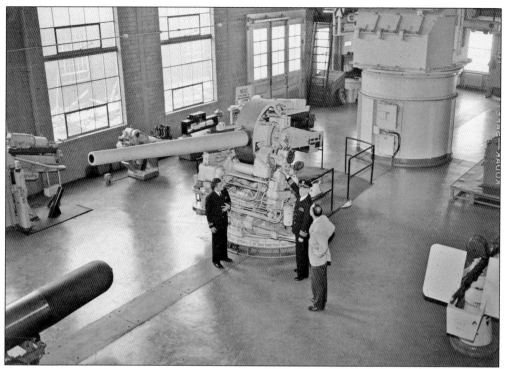

Navy guns and other equipment used for Naval Reserve Officers Training Corp (ROTC) instruction are featured prominently in the 1951 photograph above taken in the Naval Science Building, later Dougherty Hall. Today, the two-story room doubles as an armory and gymnasium shared by both Air Force and Army training units (the Army unit was established in 1984). A Naval unit moved into the new Naval Science Building on Eastern Parkway at Third Street in 1947. (Despite the closing of the Navy unit in 1979, a naval officer's seal remains on the building pediment.) When the Navy left in 1981, the 30-year-old Air Force ROTC moved in and the building was renamed for law alumnus Russell E. Dougherty, retired commander of the Air Force Strategic Air Command.

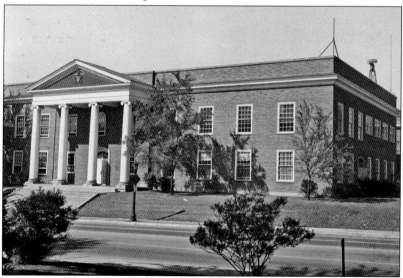

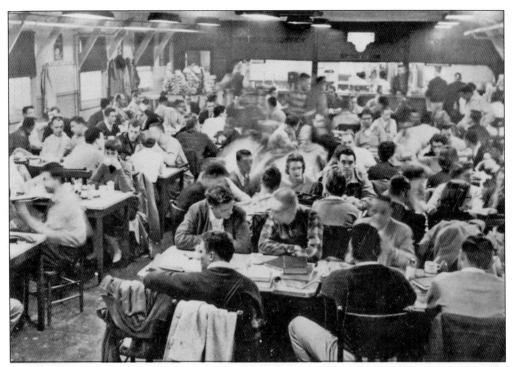

The Fine Arts Building (located to the rear of Schneider Hall) was built as the mess hall for the Naval V-12 program. From 1946 to 1959, the frame structure, which was later enlarged with a formal dining room (Jefferson Room) and covered with brick veneer, served as the main dining facility for the campus. UofL athletes ate in a special room in the basement, and alumni who worked nearby frequently stopped for lunch. Later, until its demolition in 1993 to make room for Lutz Hall, the building housed the fine arts department studios and slide room.

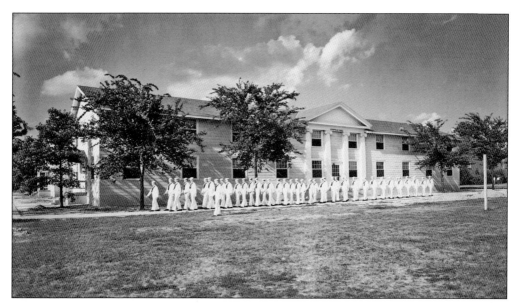

In 1943, a feared enrollment drop was prevented when 475 Navy V-12 officer cadets enrolled. Otter, White, Leopold, and Menges Halls (named for students killed in action) and a cafeteria were hastily financed to accommodate the sailor students. The four "temporary" barracks sat behind the administration building and functioned there for 12 years; they were so useful that in 1955, to make room for the library (Schneider Hall), they were relocated to where the Chemistry Building now sits and used for another 24 years. Among their many uses, they housed the first men's dormitories and the first homes for the School of Business and Southern Police Institute. A 1993 memorial behind Schneider Hall recalls the four young men for whom the V-12 dormitories were named, as well as the University of Louisville Naval ROTC unit that was formed when the wartime program ended.

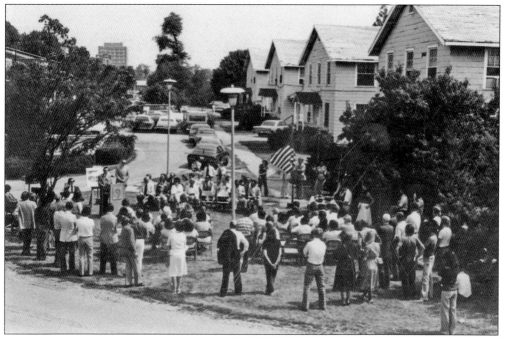

Until the very early 1950s, the University of Louisville admitted only white students, with one exception. Following a 1925 political arrangement involving African American support for a local tax referendum largely benefiting white UofL, the university agreed to establish an undergraduate school for blacks called Louisville Municipal College (LMC), which opened at Seventh and Kentucky Streets in 1931. (For well over 50 years previously, Kentucky's black Baptists had operated on that same campus an institution of higher learning variously called the Kentucky Normal and Theological Institute, State University, or Simmons University.) LMC football cheerleaders from the 1940s are shown below at Central High School, where many of the school's games were played. The University of Louisville, after fully integrating all its programs in 1951, closed Louisville Municipal College.

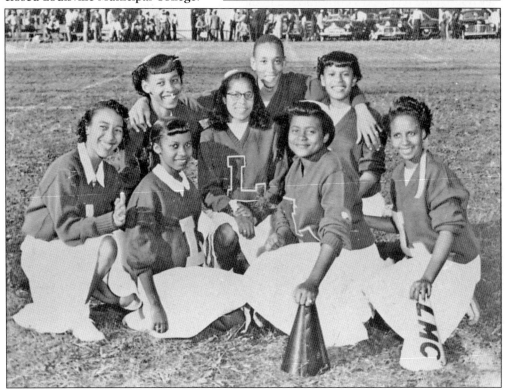

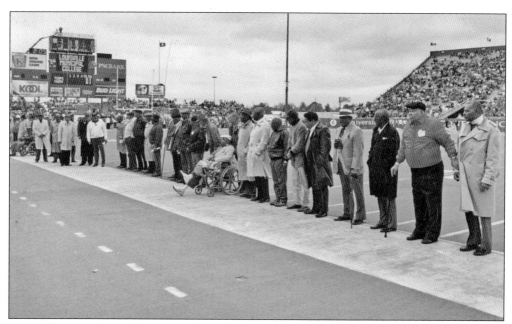

Louisville Municipal College's football team played a rigorous schedule against traditionally African American schools, including the prestigious 1947 Vulcan Football Bowl against Tennessee Agricultural and Industrial College, which they sadly lost. That appearance marked the first ever bowl game by any University of Louisville football team. Over its 20-year existence, Municipal also suited up teams in tennis, track, and both men's and women's basketball. Former LMC athletes (above) were honored in 1995 at the homecoming game in Cardinal Stadium at the Kentucky Fair and Exposition Center. The Louisville Municipal College Bantam football team is pictured below in front of campus buildings. The man sporting a hat and glasses in the back row is faculty member Charles Henry Parrish Jr., who later was invited to join the faculty on Belknap Campus.

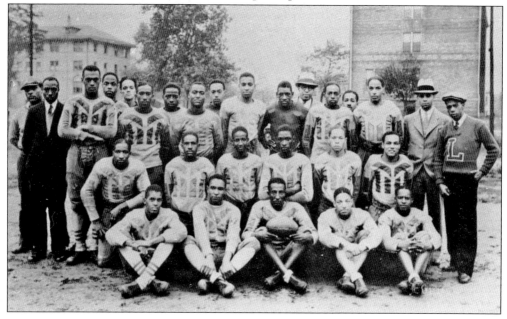

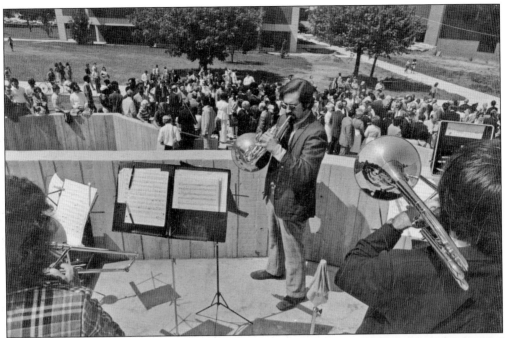

In 1974, the new Ecumenical Center (since renamed the Interfaith Center) at First and Barbee Streets housed religious programs for Jewish, Catholic, and a collection of Protestant denominations under one roof. The dedication ceremony is pictured above. Previously, those ministries had offices in the student center. Just a year after the Ecumenical Center opened, the Southern Baptists, having been displaced in 1967 by campus growth, opened a new student ministry next to the Ecumenical Center. Both buildings were funded by private sources. Before that, in the 1950s, student religious groups frequently gathered for separate lunch meetings on the second floor of the Dean's Building. The Baptist Student Center was located in houses near campus until 1957, when the building shown below (near the Loop Hole restaurant) was built across from the university on the north side of Shipp Street.

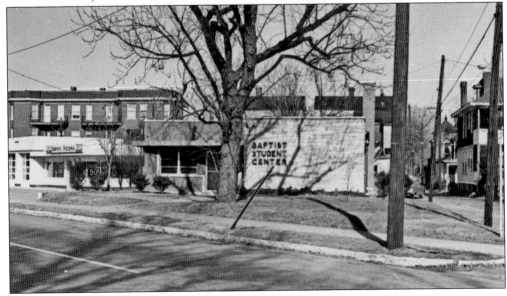

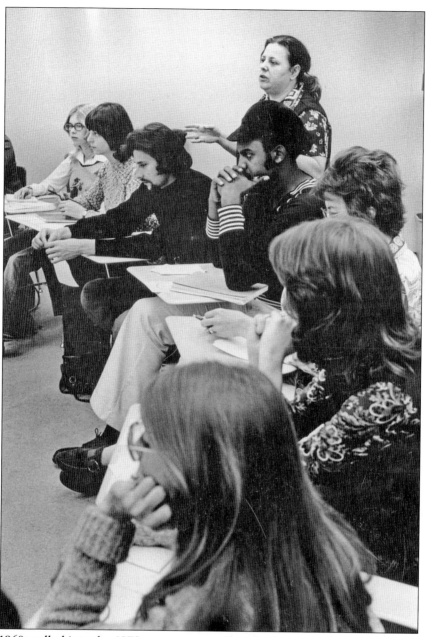

As the 1960s rolled into the 1970s, war, race, and curriculum were front and center among student activists. The "free university" movement, starting in 1969, charged that traditional college courses and teaching methods failed to address the life issues that students faced or the sometimes controversial topics that interested them. Persuading the university to provide classroom space, the students organized and frequently taught free classes that included gay liberation, Hebraic thought and culture, history of the German air force, and how to become a vampire. After being somewhat mainstreamed under the sponsorship of student government, the free university died out in the early 1980s. Here, clairvoyant Millie Rubin leads her students through a series of mind exercises during an extra sensory perception (ESP) class in 1974.

Four

RECOLLECTIONS

Before the 1960s, UofL remained mostly a "streetcar college," with fewer than 300 beds plus very limited housing provided by Greek organizations. The Eastern Parkway and Second Street routes provided direct commuting service to campus, while the Fourth Street line ran very close. Actually, Louisville's last streetcar ended on Derby Day in 1948. Today, abetted by a requirement that almost all first-year enrollees must live in university housing, UofL is now a vibrant place, with some 7,000 students living on campus.

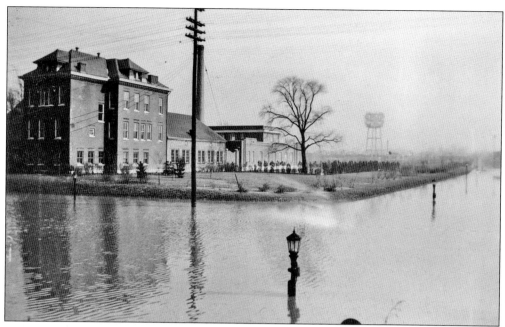

University classes were suspended for several weeks during the great Ohio River flood of 1937, when Belknap Campus became an island surrounded by a sea of icy, muddy water. Fortunately, the worst damage was confined to basement level spaces. In August 2009, several buildings on the north side of campus took on water during a massive flash flood forcing the temporary relocation of some offices and student housing. This photograph of the 1937 flood was taken at Third Street and Eastern Parkway. Patterson Hall is shown.

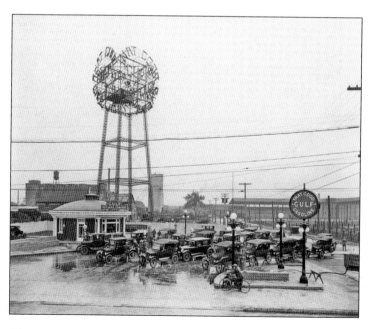

In 1925, the same year the University of Louisville moved to campus, a Gulf service station opened across Brook Street on the corner of Warnock Street (now University Boulevard). The steam\chill plant now occupies the site. A giant four-faced neon "Good Gulf" sign tower called attention to the business for blocks away. A streetcar loop gave fans convenient access to Parkway Field, just beyond Eastern Parkway.

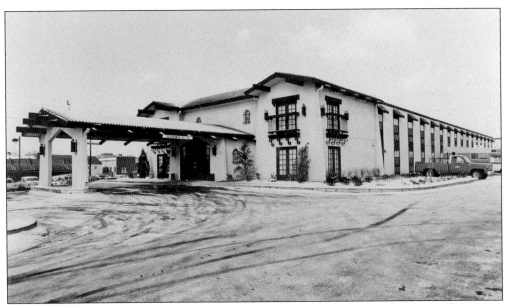

Cardinal Hall was a short-lived dormitory, from 1988 to 1996, located next to the McDonald's on Warnock Street. The converted La Quinta Inn was, at the time, considered pretty posh for a student residence, given the private bathrooms, carpet, and color television. The building was demolished for parking, and the location is now part of the Cardinal Park sports complex.

Students endured long lines waiting to purchase textbooks in the bookstore on the lower level of the student center now called the Miller Information Technology Center (MITC). As early as 1933, the student newspaper reported complaints regarding the cost of textbooks. From the beginning, the bookstore offered more than just books: snacks, souvenirs, and fraternity/sorority collectibles also lined the shelves.

Outdoor commencement exercises on the oval in front of the administration building started in the late 1940s, but the threat of stormy weather always posed a problem. In addition, the number of graduates was on the rise, and it was costly and time-consuming for the maintenance staff to set up 7,000 folding chairs on that thick turf. The rainouts of 1955 and 1956 certainly dampened spirits, but it appears that being forced indoors both in 1983 and 1984 sealed the outdoor commencement's fate. Except for one final ceremony on the oval in 1986, university commencement has been held indoors, first at the Kentucky Fair and Exposition Center, and more recently at the KFC Yum! Center.

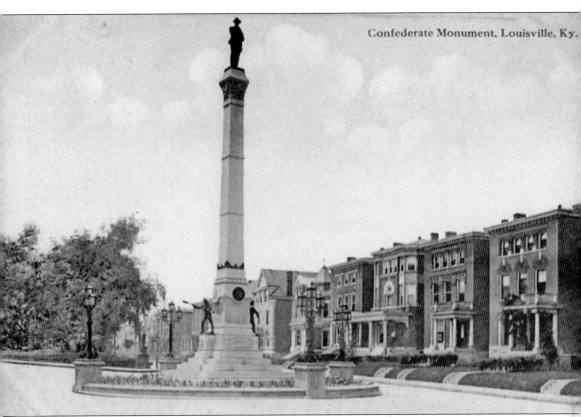

Confederate Monument, Louisville, Ky.

This 1895 monument to the Confederate Civil War dead was erected in the middle of Third Street near the Speed Museum. The stone shaft, topped by a lone Confederate soldier facing north, was paid for by the Kentucky Women's Confederate Monument Association. As early as 1921, the Louisville works department viewed the monument as a traffic hazard and called for its relocation. Further removal calls were heard in the 1950s and 1960s, ultimately joined by voices who viewed the statue as racially offensive. Meanwhile, the university expanded westward far beyond the site, creating the impression that the monument was part of Belknap Campus. In 2011, the university created Freedom Park adjacent to the obelisk to honor participants in the long struggle for racial justice. Four years later, the park was named for Charles Parrish Jr. In 2016, the city relocated the Confederate Monument to Brandenburg, Kentucky.

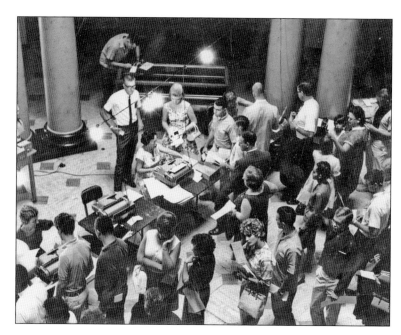

A rite of passage for decades, students used to stand in long lines to sign up for classes. Here, undergraduates scrutinize course offerings in the basement of Grawemeyer Hall. Arena registration in Bigelow Hall in the MITC left throngs of collegians with nightmares over closed classes, prerequisites, and computer crashes.

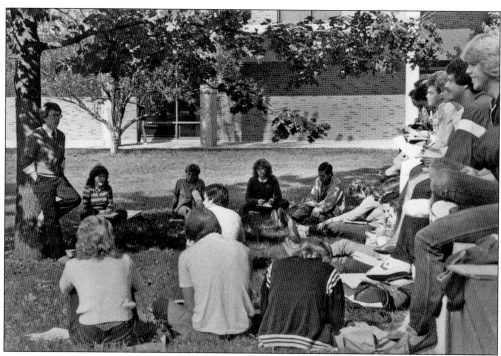

A shaded grassy quadrangle has become one of the special places on Belknap Campus. It was formed where old met new: House of Refuge buildings like Gottschalk, Gardiner, and Ford Halls on one side, and the newer Bingham Humanities, Life Sciences, and Ekstrom Library buildings on the other sides. Here, a class takes advantage of beautiful weather along the wall of the Humanities Building.

Parking is a continuous battle on many college campuses, and the University of Louisville is no exception. These days, most students park at Papa John's Cardinal Stadium and take shuttles that traverse a loop from Central Avenue to Third Street, then across Cardinal Boulevard to Floyd Street and back to the stadium. In the past, students parked in nooks, alleys, and huge gravel lots nicknamed Timbuktu, Alaska, and Siberia that extended over a square mile from Interstate 65 to Floyd Street.

The Louisville Mootz

Fou d'Avrile Copyright, 1984, THE LOUISVILLE MOOTZ April 2, 1976

In the late 1970s, Belknap Campus was struck with the "Mootz" graffiti craze. The use of this word of unknown origin (written with a diagonal line through the "z") sadly included unwelcome graffiti on some university property. The phenomenon grew so popular that the entire 1976 April Fool's edition of the *Louisville Cardinal* was renamed *The Louisville Mootz*.

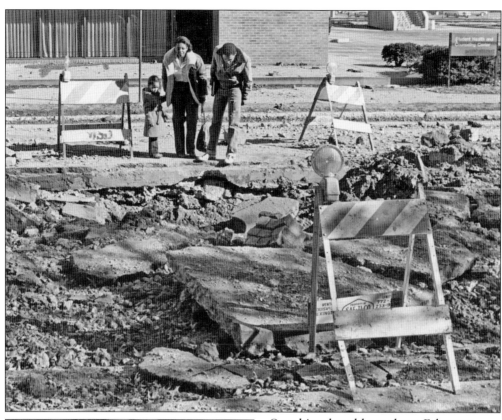

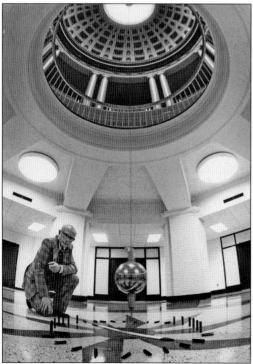

On a bitterly cold pre-dawn February morning in 1981, campus quiet was shattered by a devastating explosion along Brook Street, hurling asphalt and stone onto adjacent university buildings and leaving a crater in the street. A valve on a tank at a nearby soybean processing plant failed, spilling its highly volatile contents into a combined sewer that crossed campus.

The Foucault pendulum hangs from the top of Grawemeyer Hall's 73-foot interior dome and dramatically illustrates the earth's rotation as the fob swings back and forth in the same direction, while the earth slowly circles beneath. The golden orb was built in the late 1970s by retired astronomer Walter Lee Moore and physicist Roger Mills, at the urging of registrar John Houchens. John Dillon—himself a physicist and, later, academic affairs vice president—is shown.

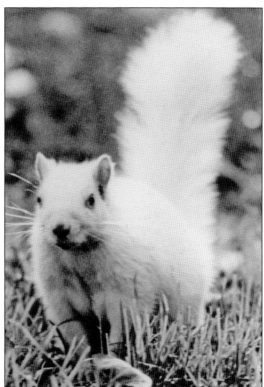

Belknap Campus boasts a population of rare white squirrels. According to beloved arts and sciences biologist Dr. William Furnish, who grew up across from campus, the critters have been here since the 1930s. In 2006, the admissions office introduced the "I Spotted the White Squirrel" contest, and winners received a T-shirt. (Below, courtesy of Megan Adams.)

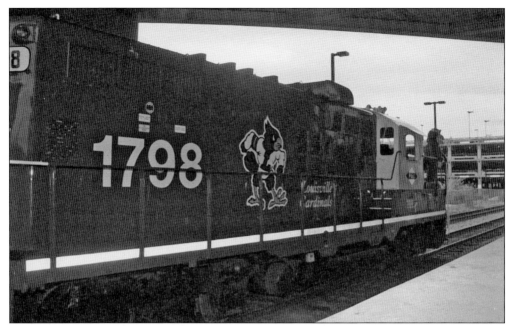

The Paducah & Louisville Railway dedicated the *Cardinal* engine No. 1798 on April 17, 1995. The locomotive, numbered to recognize the date of UofL's founding, carried the bicentennial message across western Kentucky. The promotion highlighted crossing safety through the railroad's Operation Lifesaver program. After a fire in 2015, engine No. 3801 replaced the earlier model.

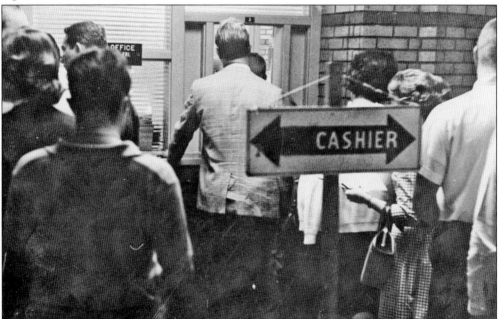

In the days before online registration, students stood in long lines to pay tuition bills. Though planned to house central administration, Grawemeyer Hall was crowded. From the 1920s until the mid-1950s, the building was home to the president's office, classrooms, the library, the registrar's office, the bursar, and bookstore.

Five

HANGOUTS

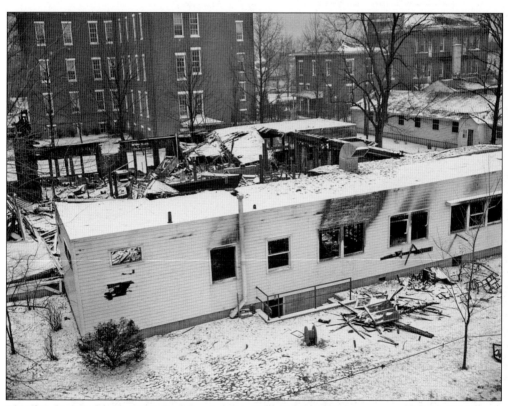

This former World War II United Service Organization building was moved from Fort Knox to campus in 1947, providing office space for student groups including the Thoroughbred, Alpha Phi Omega, Playhouse, Prologue, and the student council. The Student Union Building included a snack bar (later renovated to a full-service cafeteria), reading rooms, and an auditorium. Fire swept through the building on January 24, 1951.

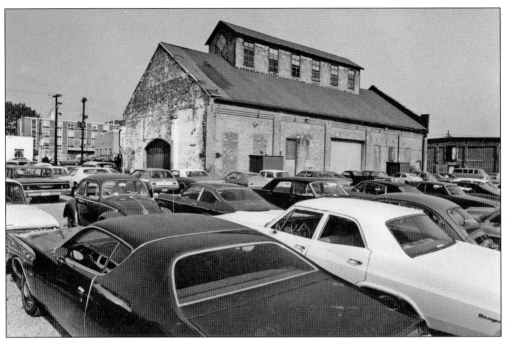

Caldwell Tanks did metal fabrication and welding in the 5,000-square-foot shop located on Brook Street across from the second Cardinal Inn until the university purchased the industrial property in 1969. Enterprising students gained permission to use the uninviting, ramshackle building for concerts, dances, and movies. The Red Barn was a success, and with the backing of George Howe, Harold Adams, and President Strickler's wife, Florence, the university completed a major renovation in 1979 that provided exterior improvements along with a stage, lighting, and sound equipment and an addition. In 1992, the Red Barn Alumni Association established a scholarship in Florence's name, as she was known as the "First Lady of the Red Barn." In 2007, it was officially dedicated as the George J. Howe Red Barn for the longtime director of student activities.

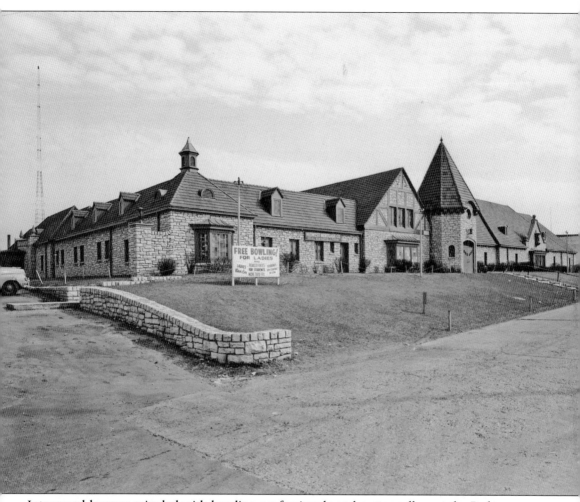

Intramural leagues mingled with bowling professionals and gutter-rollers at the Parkmoor Recreational Center. The alley, which operated all night, was located on Third Street across from the Reynolds Building between the two railroad trestles and was one of the region's largest. The facility, built in 1941 with elegant gables and towers (pictured), ultimately had 52 lanes plus pool tables, a restaurant, and a dance floor. After a devastating fire in late 1960, Parkmoor was rebuilt with a somewhat simpler design. The death knell for Parkmoor sounded in 1994 when the building was demolished for expanded UofL parking. Now, the site is part of a much larger parcel slated for development as an engineering research park.

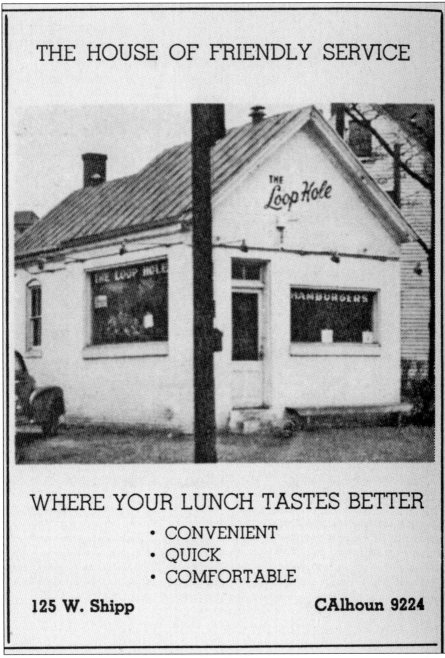

THE HOUSE OF FRIENDLY SERVICE

WHERE YOUR LUNCH TASTES BETTER

- CONVENIENT
- QUICK
- COMFORTABLE

125 W. Shipp **CAlhoun 9224**

The Loop Hole restaurant had several lives. The first likely began in the late 1940s in an abandoned streetcar turnaround waiting room where Shipp Street approached Barbee Avenue and Second Street. The small one-room diner's slogan was "where your lunch tastes better." In the late 1950s, a new Loop Hole was constructed on the same site, but this time it was connected to a modern enamel-paneled Pearson's Amoco service station. For some years, before yielding to campus expansion in about 1966, the Loop Hole site was occupied by Codispoti's Pizza. After African American students arrived on Belknap Campus, several of the near-campus eateries refused sit-down service to blacks at various times.

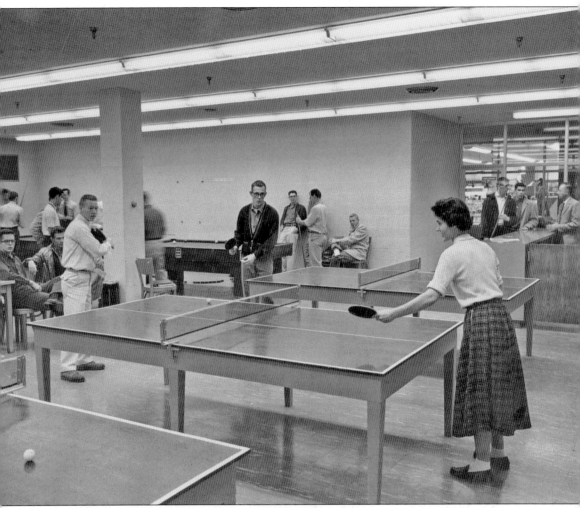

The student game room, located in the student center (MITC), was a popular escape from the rigors of academe. Robert Burckle, also known as "Mr. B," who supervised the room throughout the 1970s and early 1980s, is remembered as a dapper dresser who always had a listening ear for students. After a 1979 move to the lower level opposite the bookstore, one game room attendant wished the facility would attract more women students and noted that a new computerized "space game" was the most popular attraction. When the SAC opened in 1990, the Cardinal Corner continued the video game tradition and also offered riveting board games, attracting 40,000 user visits annually.

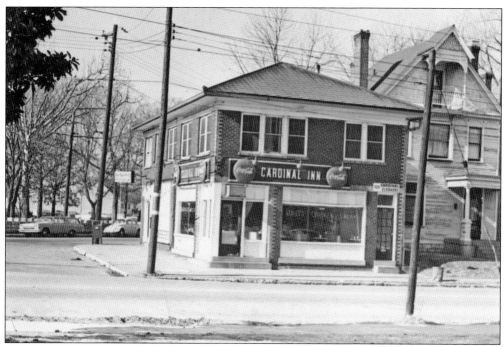

A succession of Cardinal Inn restaurants served as hangouts for well over a half-century. In the mid-1920s, the Cardinal Inn opened directly across Shipp Street from Gottschalk Hall at the corner of First Street. It is hard to believe that, as the 1930s window sign indicates, one could buy a sandwich for just 10¢. In the early 1930s, the university president dispatched two detectives to investigate possible illegal activity at the restaurant. Their report indicated pretty predictable behavior like excessive familiarization in the booths, card playing, smoking, and of course, wrestling with the all-too-popular pinball machines. (Below, courtesy of Betty Smith.)

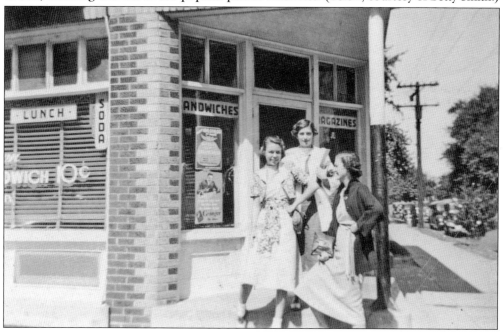

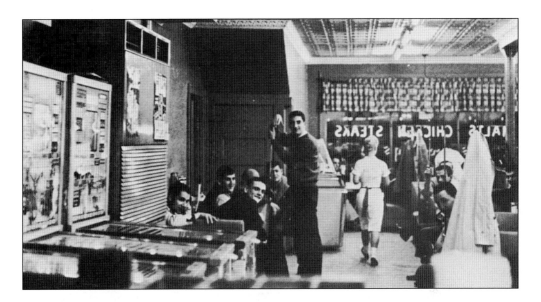

The signs in the windows indicate that malts, steaks, and chicken were featured. For over 30 years, throngs of students ate, talked, studied, and got into mischief in the beloved dive until, in 1967, the Urban Renewal project forced the George family to relocate its popular eatery. The Bingham Humanities Building's southeast corner now occupies the site where that first Cardinal Inn stood. Stevenson Hall, on the other side of First Street, is visible in the background of the demolition photograph below.

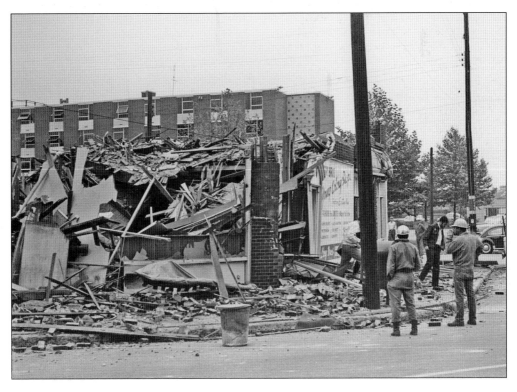

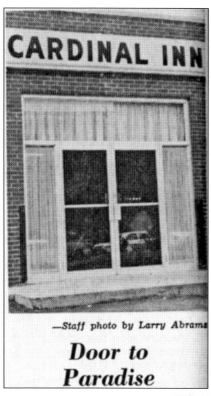

—*Staff photo by Larry Abrams*

Door to Paradise

The Cardinal Inn moved in 1967 to a nondescript concrete block building on Brook Street just north of Barbee Avenue, facing the Red Barn. The George family, in honor of their Middle Eastern heritage, frequently had a Lebanese entree on their cafeteria-style hot table. Patrons could start their day with early morning breakfast and linger a long while over a newspaper while engaging in endless talk about sports. A pay phone down a darkened hallway attracted heavy use. In 1978, university expansion took this Cardinal Inn as well.

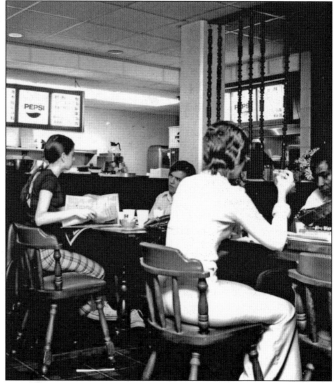

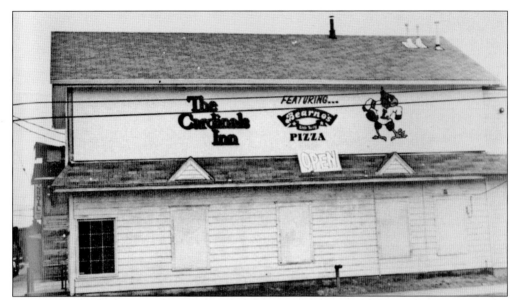

With a very subtle name change, the Cardinals Inn (adding an "s") at the corner of Brook and Lee Streets, across from DuPont Manual High School's athletic field, operated in the 1980s and 1990s. By that time, the sports bar culture dominated, and UofL ballgame watch parties were common, while the upstairs became a destination for local bands.

A waist-high stone wall with entrance columns, inherited from the House of Refuge, defined Belknap Campus's northern boundary at Shipp Street for many decades. Much of the wall was dismantled when the street was closed for campus expansion in the 1960s. Happily, much later, some of the stones were relaid to further beautify Parrish Court, a lovely plaza developed in 1977 on the site of the Dean's Building. A small section of the iconic wall remained alongside the Speed Museum until around 2012, when it was removed to make way for an addition.

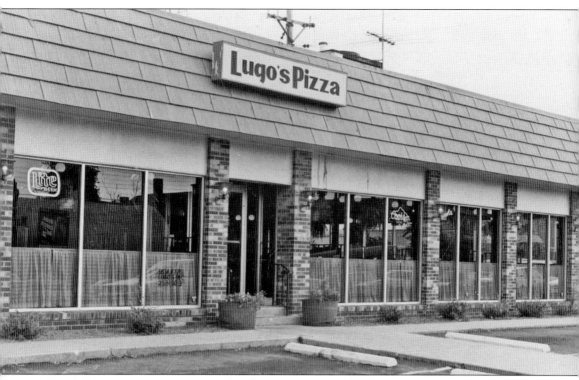

Lum's Restaurant, a near-campus hamburger eatery on Third Street opposite the driveway to the Reynolds Building, opened its doors in about 1970 on the site of a former Surety service station. Lugo's Pizza occupied the building from 1980 to 1985 until the Speed School's Engineering Graphics department took over. The old restaurant site was demolished in 2013 for the proposed Belknap Engineering and Applied Sciences Park (a technology job incubator), which also includes the former sites of Kentucky Trailer Company (earlier called Kentucky Wagon Works), Parkmoor Bowling Lanes, and radio station WLOU. The entire site has been fully cleared except for the old dropforge shop. While there have been infrastructure improvements at the research park (including a new road connection with two railroad track "flyovers," construction has not begun, and the old restaurant site is currently part of an enlarged campus parking lot.

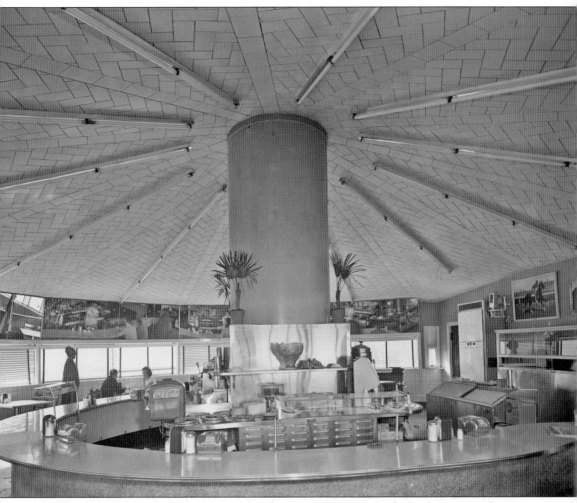

The Masterson family ran a popular restaurant on the corner of Third Street and Avery Avenue (now Cardinal Boulevard) for 65 years. Starting in 1950, they called their café the Hollywood Steak House, featuring both indoor and curb service. The circular counter was a popular short-order stop to get a late-night burger or to stage a coffee-filled all-nighter while cramming for an exam. In conjunction with a 1962 exterior redesign and expansion, the landmark was renamed Masterson's Steak House and remained a favorite dining and banquet facility until 2010, when it was demolished to make way for Cardinal Towne, a development consisting of restaurants and student apartments. Cardinal Towne provides an urban pedestrian-scale edge where Belknap Campus meets the Old Louisville neighborhood. Interestingly, at one point in the late 1960s, Masterson's reacted to the student counterculture movement by banning long-haired patrons.

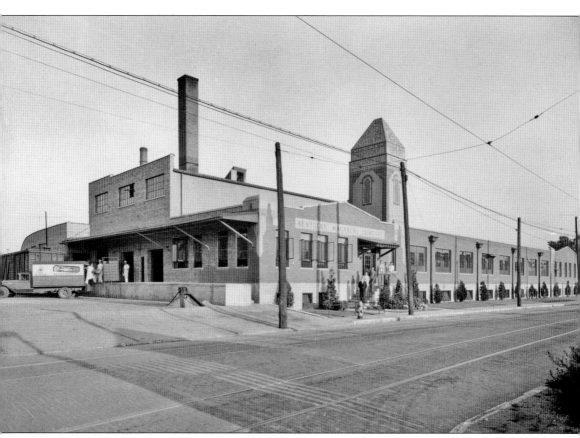

On Wednesdays, students and faculty joined area industrial workers and others in the community for an inexpensive spaghetti lunch at the Delmonico pasta plant located just beyond the rail crossing on South Floyd Street. University of Louisville athletes ate free, others paid 50¢ for noodles and plain sauce, plus 25¢ more for meat. The building shown had been considerably altered by the time the plant closed in 2002 to make way, in 2014, for the Mark and Cindy Lynn Soccer Stadium.

Six

SPORTS

In the early years, cheerleading tryouts were held on the oval and attended by most of the student body, and competitors were judged on crowd response, technique, and energy. Sherrill Brakemeier, physical education professor and team sponsor, remembered that the early squads had to provide their own uniforms and pompoms. The Cardinals have won 17 National Cheerleading Association championships, including 9 of the last 14.

CAPTAIN
ETHELMAE TUELL
BUSINESS MGR.
ADA SARA LINKER

CHAMPIONSHIP CUP

The year 1909 marked the women's basketball team's inaugural season, consisting of just two games. Their only opponent was the Young Men's Hebrew Association female squad, which earned victories in both outings. Olive Henderson coached the UofL crew of 15 women. The program continued to build momentum, traveling by rail to play opponents as far away as Nashville. In 1917, the women were crowned state champions, and in 1922, they brought home the Girls' Intercollegiate Basketball Championship of Kentucky. Arts and sciences dean John L. Patterson celebrated the women's achievement by presenting a gold pin to each player.

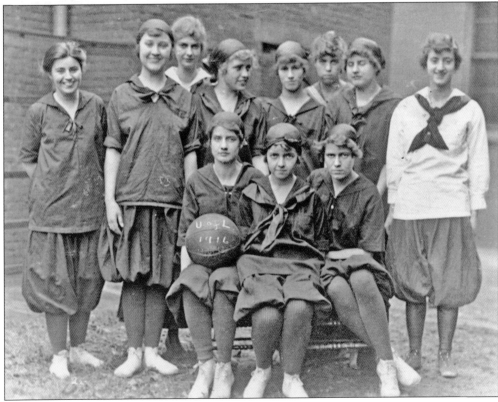

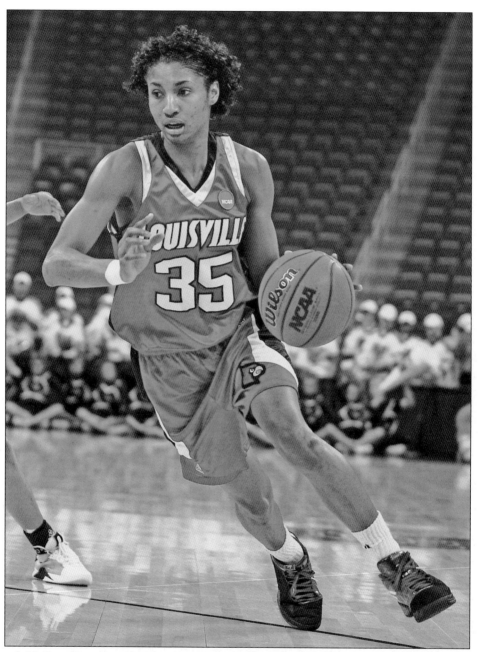

Angel McCoughtry was the first women's basketball player to have her jersey retired. McCoughtry wore No. 35, the same as Louisville legend Darrell Griffith, whose record she broke to become the highest-scoring basketball player ever at the University of Louisville, male or female, with 2,779 points. She ranks in the top 25 all time in National Collegiate Athletic Association Division I history. In 2009, McCoughtry led the Cardinals to their first national championship game and was named Player of the Year in 2007 and 2009 for the Big East Conference. She was the number-one overall draft pick of the Women's National Basketball Association, going to the Atlanta Dream, where she captured all-league honors in 2010, 2011, 2013, 2014, and 2015.

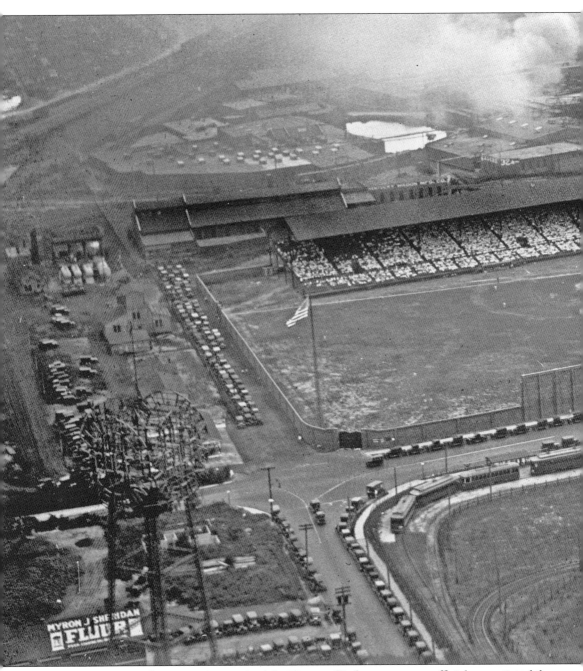

MYRON J SHERIDAN
FLUOR

At the same time the university acquired the House of Refuge property, officials negotiated the sale of eight acres along Eastern Parkway to the Louisville Baseball Company for its Triple-A professional team, the Louisville Colonels. Parkway Field included grandstand seating for 13,500 fans and was the first stadium to have theater-style fold-down chairs. Opening on May 1, 1923, the overflow crowd of 18,000 witnessed the Colonels win against the Toledo Mud Hens with a score of 5-1. In December 1953, the university repurchased Parkway

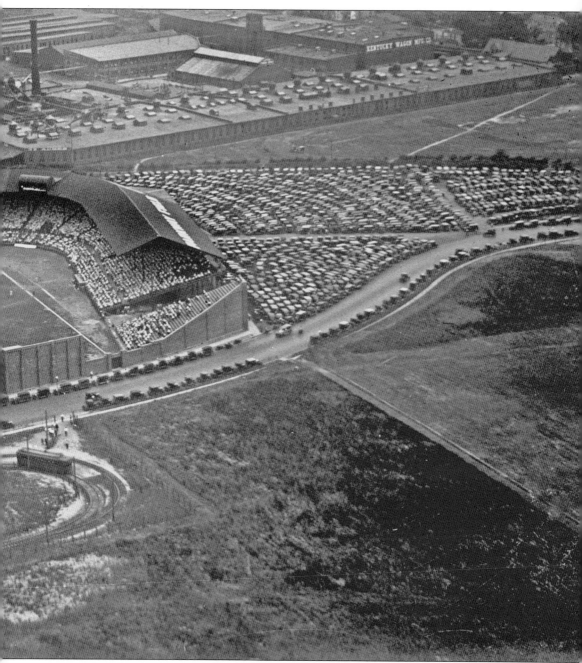

Field, and the Louisville Colonels continued to play there until 1956, when it became UofL baseball's home field. After four more decades, UofL baseball moved to Cardinal Stadium at the Fairgrounds. The field was renovated in 2005, and today is the Student Government Association Parkway Field, hosting intramural flag football, soccer, ultimate Frisbee, and kickball, as well as a variety of club sport events. Bricks from Parkway's long-ago razed left field wall were reused at Jim Patterson Stadium, the current home of Cardinal baseball.

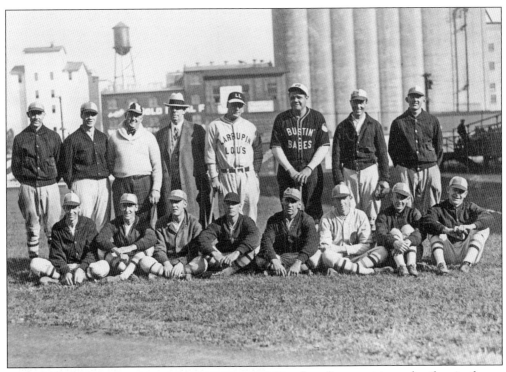

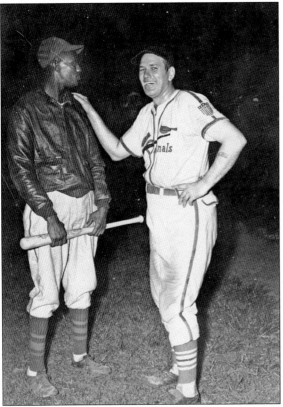

Standing next to each other in the center of the above photograph, Lou Gehrig and George Herman "Babe" Ruth are pictured at Parkway Field along with teammates in 1928. Many notable players competed there. Jack Roosevelt "Jackie" Robinson played in his first professional playoff game in September 1946 with the Montreal Royals (a farm team of the Brooklyn Dodgers). Other greats include William Jennings Bryan "Billy" Herman, Earle Combs, Joe McCarthy, William "Bob" Uecker, Grover Cleveland "Slim" Lowdermilk, and James "Jimmy" Piersall. Harold "Pee Wee" Reese played his rookie season in Louisville. The park was also the home of the Louisville White Sox of the Negro National League in 1931, the Louisville Black Caps of the Negro Southern League in 1932, and the Louisville Buckeyes of the Negro American League in 1949. At left, Leroy "Satchel" Paige jokes with J. Hanna "Dizzy" Dean at Parkway Field during an exhibition game.

Nestled between Papa John's Cardinal Stadium and the Patterson Baseball Stadium, 13 black and red cabooses sit on a railroad track stub on the site of the former L&N Railroad South Louisville shops. The cabooses have been retrofitted as hospitality rooms for entertaining during football and baseball games and other events.

The year 1997 marked the end of a 20-year football tradition of cannon fire to start each half and after every University of Louisville score. During the October 11 game against Tulane University, just after halftime, a Triangle engineering fraternity member was injured when, while reloading the artillery, it discharged, causing burns and lacerations to his hands and face. Here, President Miller prepares to fire the cannon in 1975.

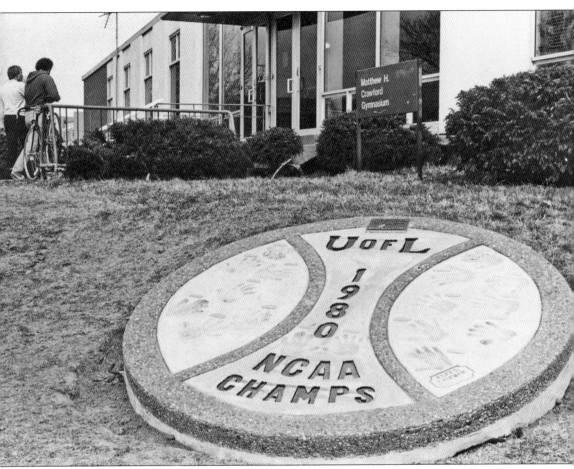

Louisville's men's basketball team is the only college team in the country to attain the championship in the three major national post-season tournaments: the 1948 National Association of Intercollegiate Basketball (now the NAIA), the 1956 National Invitation Tournament (NIT), and the National Collegiate Athletic Association (NCAA) in 1980, 1986, and 2013. The 1980 team led by Darrell "Dr. Dunkenstein" Griffith overcame a late game deficit with a 9-0 run to finish victorious over University of California Los Angeles. This concrete basketball sculpture emblazoned with the handprints of the team was located just outside Crawford Gym. It is currently in storage until the new academic building, under construction on that site, is completed.

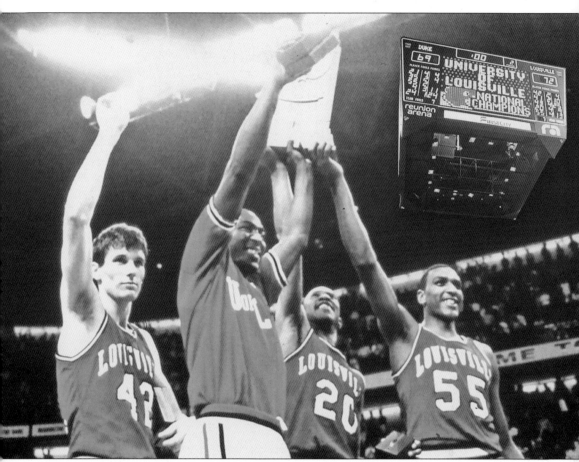

At Reunion Arena in Dallas, Texas, the Cardinals beat Louisiana State University in the national semifinal and dispatched Duke University to win the 1986 NCAA national championship. "Never Nervous" Pervis Ellison was named the tournament's Most Outstanding Player, the first time since 1944 that a freshman gained the honor. A raucous celebration back in Louisville had fans so excited that some climbed onto the roof of the players' bus, preventing the team from entering Freedom Hall. In a 2016 *Courier-Journal* piece, head coach Denzel "Denny" Crum reminisced, "A friend who was also a coach (Bobby Knight) told me after the game that the best team didn't win the championship this year, I said, 'The best team tonight did.' " Here, Jeff Hall (42), Robbie Valentine, Milt Wagner (20), and Billy Thompson (55) celebrate the 72-69 victory.

Cardinal baseball claims a lineage that dates back to 1909, just two years after the founding of the College of Arts and Sciences and well before the university arrived on Belknap Campus. In the early days, the team roster was supplemented by students enrolled in medicine, law, and dentistry. While consistently underfunded, Cardinal baseball enjoyed remarkable success against regional foes, with the 1957 team going undefeated against college opponents and losing only to a talented Fort Knox squad. John Heldman Jr. coached the Cards from 1937 until 1961 (except for a two-year hiatus during World II when no team was fielded), achieving a record of 309 wins, 149 losses, and 4 ties. The baseball team played in the College World Series in 2007, 2013, 2014, and 2017.

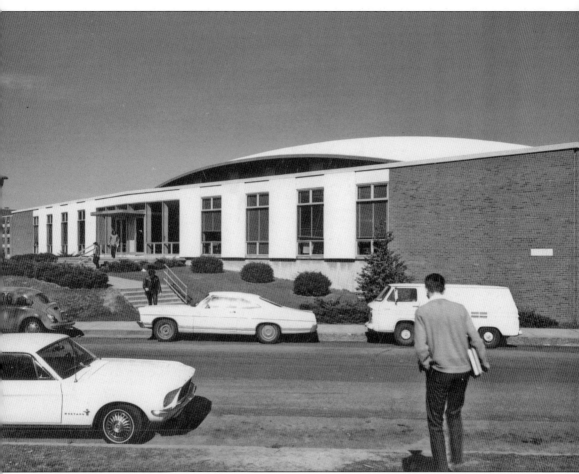

The John A. and Mary H. Crawford Gym was built in 1964 with money from the estate of their son, Matthew H. Crawford. The main floor featured two regulation basketball courts that many remember for the rousing lunchtime pickup games. UofL players mixed it up with high schoolers, college kids, professors, staff members, and members of the American Basketball Association's Kentucky Colonels for what longtime radio broadcaster Paul Rogers called some of the best games ever played inside the city limits. The lower level housed an L-shaped, six lane swimming pool, the largest in Louisville at the time of construction. The facility served thousands of students who took classes and competed in intramural sports. The 72,753-square-foot facility was razed in late 2016 to make way for a new academic building.

Ellis J. Mendelson spent four decades as head of the intramural program. His successful model brought national prominence and was highlighted in a widely circulated 14-minute movie that he produced. Mendelson was awarded the prestigious National Intramural-Recreational Sports Association Honor Award in 1980.

Intramurals thrive largely due to the Greek organizations. Longstanding traditions dating to the 1950s include the Turkey Trot (a footrace) and the Canoe Regatta. The recreational and competitive leagues, clubs, and fitness programs provide participants with exercise, recreation, and competition. Pictured here is an inter-fraternity volleyball match outside Threlkheld Hall.

The 1950s brought formal oversight, with Dave Lawrence taking over the reigns for men's intramurals and Sherrill Brakemeier supervising the women. Softball, table tennis, rifle, wrestling, bowling, handball, and volleyball were available to student athletes. In 1955, about 46 percent of male students participated in at least one intramural sport. Here, two fencers attack.

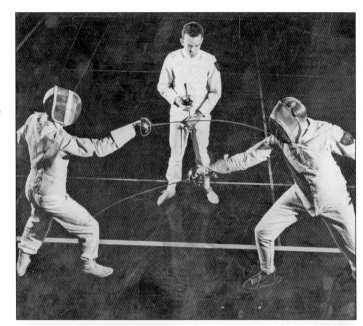

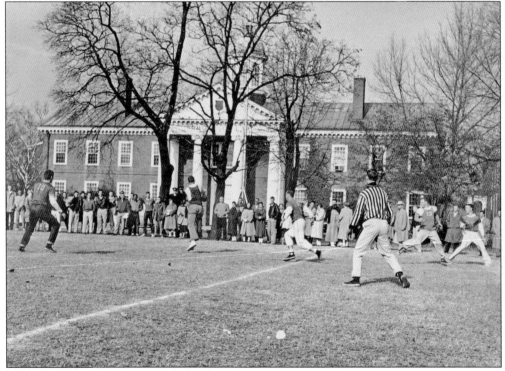

Spearheaded by the "L" Club, Intramural sports began in 1928, not long after the move to Belknap Campus, with an inter-fraternity cross-country run won by Sigma Chi Sigma. Basketball followed, with baseball, tennis, golf, track, and swimming soon after. The loosely organized effort continued to gain support and participants (women's intramurals began in 1932) with a considerable boost due to the influx of V-12 sailors. Pictured is an exciting touch football game on the oval.

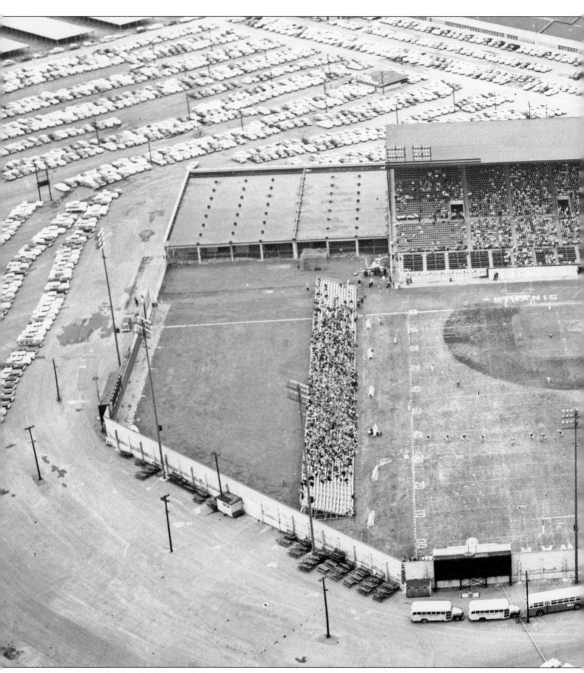

In 1957, the football team left Parkway Field to play home games at the new State Fairgrounds Stadium, beating Toledo University in the opener and going undefeated for the season. The Cardinals' new home field was constructed as a multi-sport stadium, with baseball seating for 23,000, and an additional 10,000 possible with temporary bleachers. To christen the field, the Philadelphia Eagles played the Baltimore Colts in a charity game, with proceeds going to the Kiwanis Club's Underprivileged Children's Fund. The first nationally televised

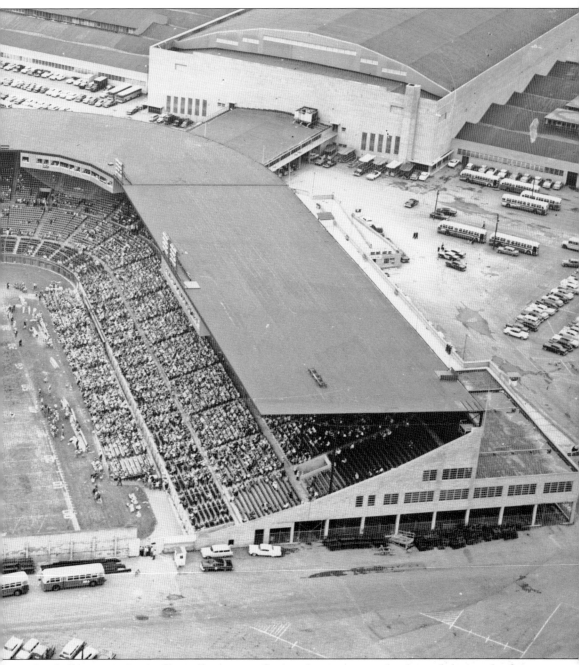

football game in Louisville, college or professional, was purposely planned during the first state fair to be held at the fairgrounds complex, but good weather and the game brought so many to the facility (96,029 gate admissions) that the surrounding neighborhoods were gridlocked with cars and walkers making their way to the fair. Over the years, the stadium was upgraded to better accommodate football. The largest Cardinal crowd assembled on September 5, 1991, when 40,457 watched Louisville take on the Tennessee Volunteers.

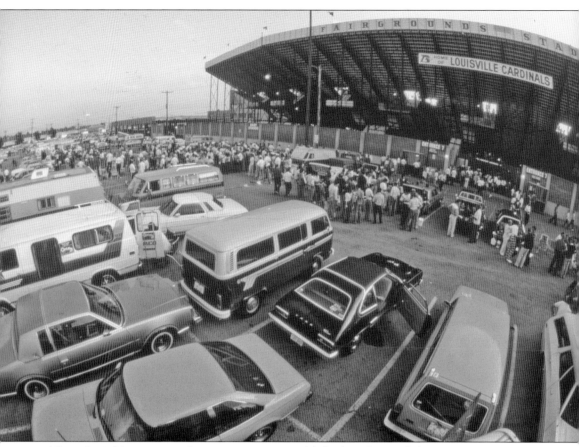

Though UofL's sports traditions are not as established as those of the Ivy League, Cardinal fans have developed some unique customs. The Crunch Zone began at Cardinal Stadium in the end zone seats of the converted baseball stadium when fans cheered through obstructed views caused by the wide support poles of the upper deck seating. Tailgating took root at the stadium, and as enthusiasm grew, so did the crowds. Local radio and TV stations broadcast live from the parking lot. Magilla Gorilla, the costume-clad fanatic fan, circled the lot on a motorcycle. The passion continues at Papa John's Cardinal Stadium, where cars and RVs line up hours before kickoff to set up in university and community lots around the stadium.

The building that would later be called the Women's Gymnasium was the second structure built after the move to Belknap Campus. Constructed as a multipurpose facility in 1931, the unadorned brick Belknap Gym sat behind Schneider Hall. It housed physical education classes, intramural contests, social functions, and most strikingly, from 1931 to 1945, was the home court of the Cardinal men's basketball team. The basket at one end was attached directly to the brick wall, a genuine hazard, and with bleachers and fixed balcony seating, only 600 fans could be accommodated. Between 1946 and the opening of Freedom Hall in 1956, the Cardinal men mostly called the downtown Armory home. In 1950, a two-story nondescript classroom/office addition was constructed at the south end of the building. After 1964, the old facility was renamed the Women's Gymnasium until it was demolished in 1993 to build Lutz Hall, a classroom building. Pictured below is the 1948 Spring Swing, where students "took time off to shake-a-leg," according to the original caption.

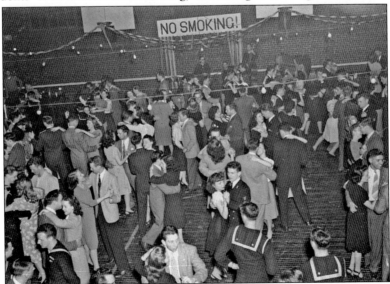

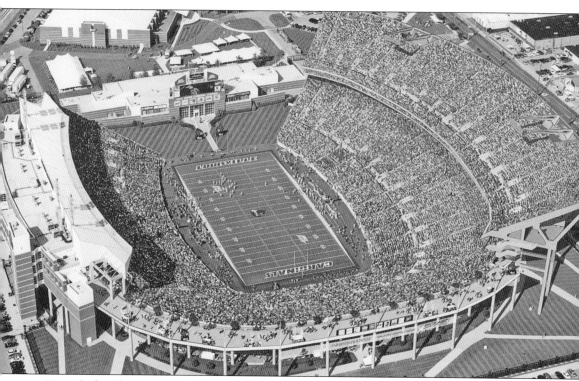

Named after the pizza company headquartered in Louisville, Papa John's Cardinal Stadium opened a state-of-the-art facility in September 1998 and concluded a decade's worth of private fundraising and commitment to the dream of an on-campus football stadium. All 55,000 seats have chair backs and armrests; when constructed, no other university owned-and-operated stadium in the nation could make that claim. The Howard Schnellenberger Football Complex, named for the famed former head coach, sits inside the stadium area on the north end and houses offices, the strength and conditioning program, and a cutting-edge training room. On the south end of the complex, the Thorntons Center of Excellence houses student-athlete academic operations. Thorntons provides a central location for all 750 student-athletes across 23 sports to obtain academic assistance to excel in the classroom. Here, the Cardinals take on the University of West Virginia Mountaineers on November 20, 2010.

Seven

STUDENT ACTIVITIES

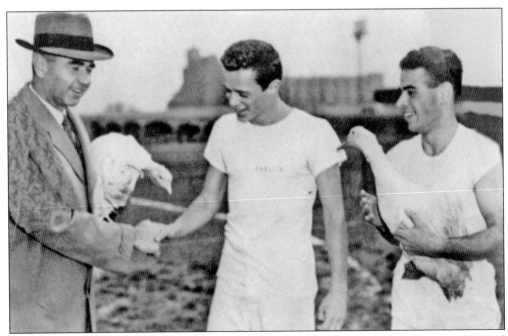

Campus foot races date back to the late 1920s. The annual intramural Turkey Trot debuted in 1953, making a claim as Kentucky's longest-running road race. In the early days, the winner received a live turkey, the second-place finisher received a goose, and the third-place prize was a chicken. Here, dean of men Dave Lawrence presents the fowl to the top two finishers in 1955.

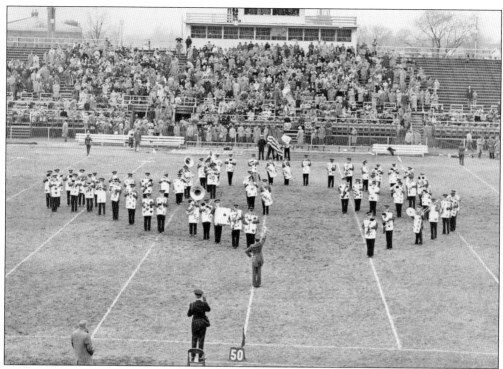

By 1933, the band was performing at football games while outfitted in uniforms donated by the famed newspaper publisher Robert Worth Bingham, but it traces its beginning to the mid-1920s. From 1949 to 1951, football games were played on the home field of duPont Manual High School. Above, the "Cards" perform. In 1949, nearly 100 in number, the group branded itself the Marching Cardinals. The ensemble is the official band of the Kentucky Derby and first began playing "My Old Kentucky Home" to crowds at Churchill Downs in 1937, as shown below on May 3, 1958, while setting up for their performance.

The student newspaper has been in almost continuous publication since September 24, 1926, when the *Cardinal News* debuted, costing 5¢. In early 1928, the no-charge *University of Louisville News* supplanted the earlier paper but lacked resources and was replaced in 1932 by the current *Louisville Cardinal*. In 1933, the editors announced an upcoming April Fools edition; the tradition continues, with the April 2017 issue marking the 84th gag edition. Some years, the *Cardinal's* staff drew the ire of the administration for its edgy humor. Above, the wisecracking "Ace Cardinal News Team" poses for the October 26, 1973, issue just before going skydiving. The *Louisville Cardinal* featured comic strips such as *Super Winston Productions*, *Part Time Patti*, and *Hall Monitor*. Editor Jim Wampler illustrated one of the most popular, *The Masked Cardinal*. The beloved strip was even produced in a few book length issues. T-shirts featuring the masked campus crusader were also sold.

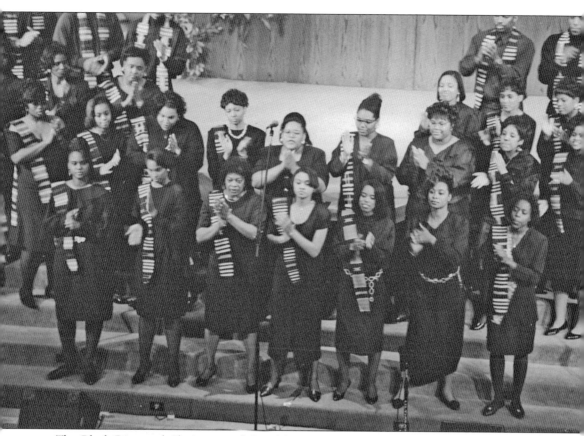

The Black Diamond Choir, one of the oldest gospel choirs in Kentucky, was organized in 1969 to promote fellowship and diversity. The idea arose from the student activism of the late 1960s, when African American students led a series of protests over a lack of black studies courses and social opportunities for black students. The student-run singing group has performed concerts across Kentucky, Indiana, Tennessee, Ohio, and Maryland. In 2000, the Black Diamond Choir embarked on its first international tour when it traveled to England. The showcase was sponsored by the US Air Force and the Royal Air Force, and arranged by Patricia Spearman, chaplain for the University of Louisville's Wesley Center.

The University Players drama group was founded in 1911. Boyd Martin, famed director, led productions from 1914 to 1955, and renowned designer alumnus Rollo Wayne built elaborate sets. Here, dramatics students perform *The Swan* on November 13, 1926, the first production after the move to Belknap Campus, presented in the renovated former chapel.

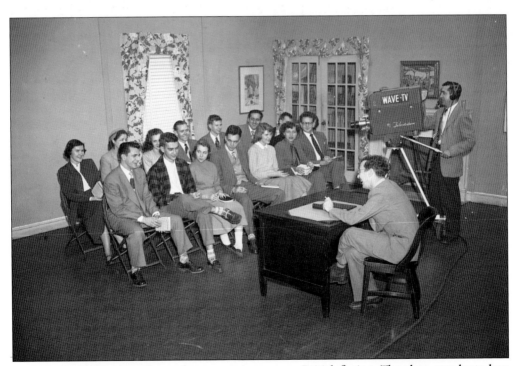

Prof. Harvey Webster teaches a class on contemporary British fiction. The class, conducted on a sound stage and broadcast by WAVE-TV, was an innovation to expand access to education to the community via modern technology. UofL also presented College-by-Radio. According to the 1950 *Thoroughbred*, UofL was the first school in the United States to present courses over a commercial radio or television station.

In 1974, the University of Louisville got caught up in the national streaking fad, with students sprinting across campus naked day and night. Things peaked in March when a clandestine ad-hoc group called the "Belknap Order of the Streak" ordered a whole week of spontaneous nudity. The event began with a nighttime sprint through the library and other campus venues and culminated in a Friday noon "streak-in" on the oval in front of Rodin's *The Thinker*, which one of the sponsors called, "The patron saint of all streakers." An estimated crowd of 1,000 gathered to watch several students sprint around the circle driveway or across the lawn, joined by a motorcade of nakedness that included passengers riding in convertibles and motorcycles. The *Louisville Cardinal* reported that the campus police winked at the hijinks.

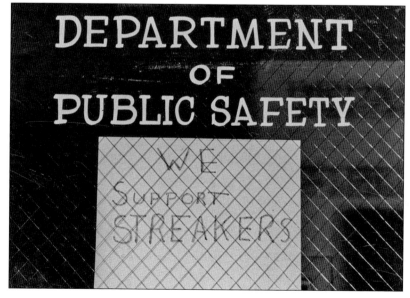

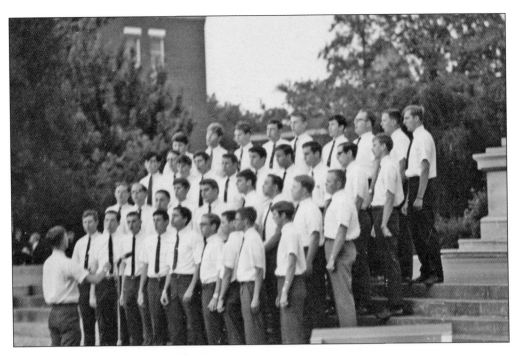

Above, in 1968, Theta Tau fraternity competes in the annual Fryberger Sing on the steps of Grawemeyer Hall. The event was first held May 18, 1938, and honors beloved music instructor Agnes Moore Fryberger. Student groups, fraternities, and sororities present choreographed musical numbers that are judged on appearance, selection, diction, artistic effect, interpretation, tone, and intonation. Below, the Kappa Deltas, in nun costumes, present "Louie Louie" in 1993.

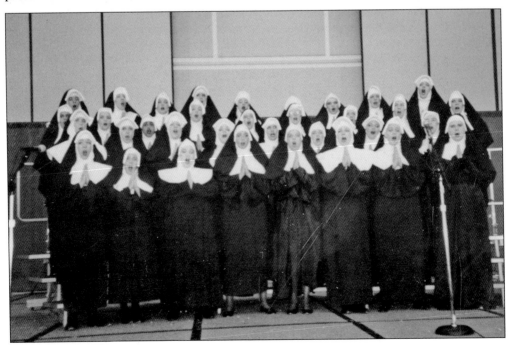

Cardinal fans are familiar with the Ladybirds dance team, but many do not know that for a few years in the 1960s, the Ulettes and the UofL Belles added flavor to halftime at sporting events. Under the direction of Patsy Bloor, the groups met weekly in the Home Economics Building (now Ford Hall) to practice routines. The Ladybirds first performed at basketball and football games in 1982, and now represent the university at over 200 appearances every year including university functions, birthday parties, and charity fundraisers. A reporter quipped, "the high kicks by the University of Louisville Ladybirds dance group rivaled those of Radio City Music Hall's Rockettes."

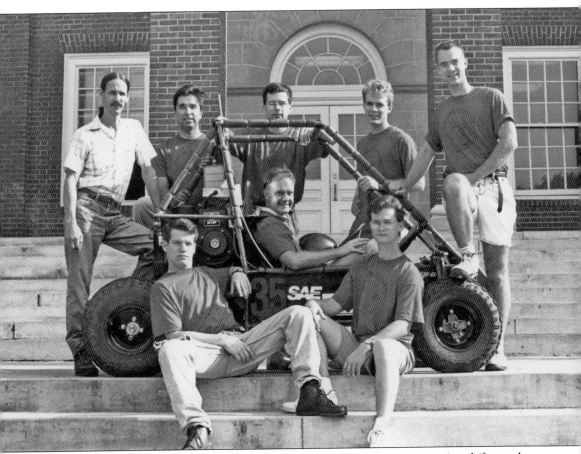

Started in 1979, SAE is a student design competition organized by SAE International (formerly the Society of Automotive Engineers) that promotes careers in automotive engineering and takes students out of the classroom to apply textbook theories to real work experiences. Speed School's SAE Baja team annually hosts Midnight Mayhem, a contest that adds a twist to other such events: darkness. The 24-hour competition includes technical inspection, dynamic events, and a timed endurance race.

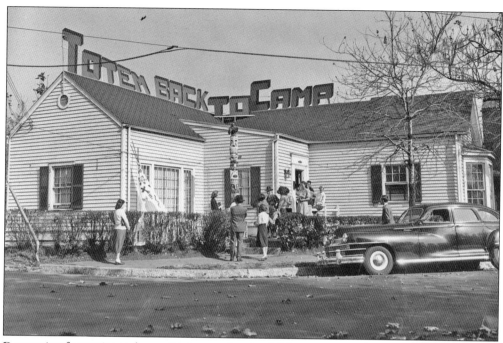

Decorating fraternity and sorority houses for the fall homecoming football game reached its zenith during the two decades following World War II. Greek houses were located throughout the immediate neighborhood across Shipp Street, as well as several of the residences along Confederate Place (now Unity Place). In 1948, the Pi Beta Phi sorority house proclaimed in the matchup with the Buffalo University Bulls that the Cardinals would "Totem Back to Camp." In 1950, the Tau Kappa Epsilon fraternity constructed a movie marquee with a cinema premiere titled "The Dukes Bite the Dust" in a contest with Duquesne University.

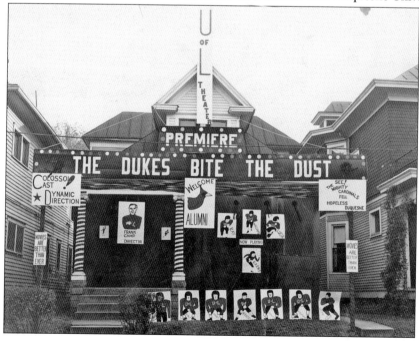

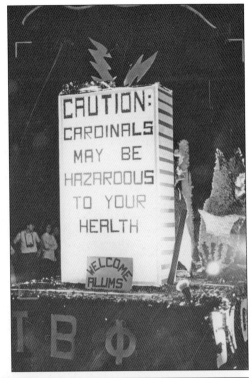

Belknap Campus organizations worked hard to compete for the title of best float in the homecoming parade. In a nighttime parade near campus, Pi Beta Phi's 1968 entry warns the Kent State Flashes that the "Cardinals May Be Hazardous To Your Health." At Third Street and Broadway in 1948, fraternity members put the Buffalo University Bulls on notice that the Cardinals had Al Capp's cartoon Schmoos (lovable, magical residents of *Li'l Abner's* Dogpatch) on their side. In the 1940s and 1950s, the homecoming parades were held downtown, and later followed a route from campus to the Kentucky Fair and Exposition Center. After a hiatus, recent efforts have revived the parade tradition with a route on campus.

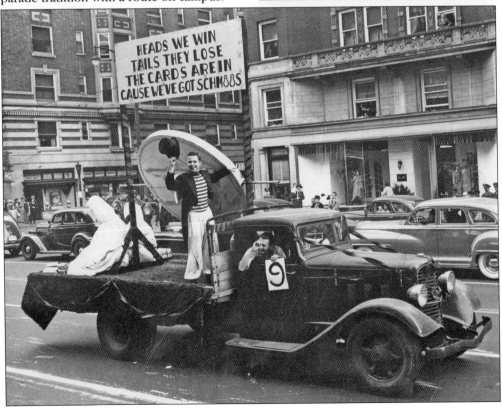

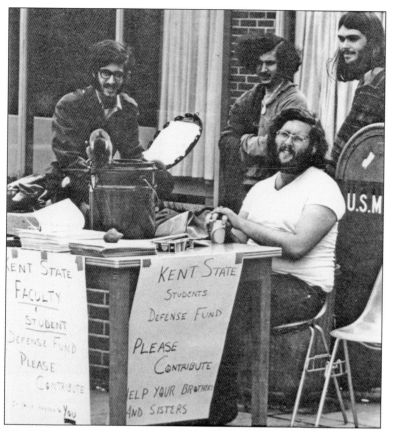

In the late 1960s and 1970s, Belknap Campus experienced strident anti–Vietnam War, environmental, and civil rights protests. Protests were held against the shooting of anti-war demonstrators by the National Guard at Kent State University in Ohio; at left, students seek donations to the Kent State Students Defense Fund. Below is a rally opposing the Marble Hill Nuclear Power Plant planned for Hanover, Indiana.

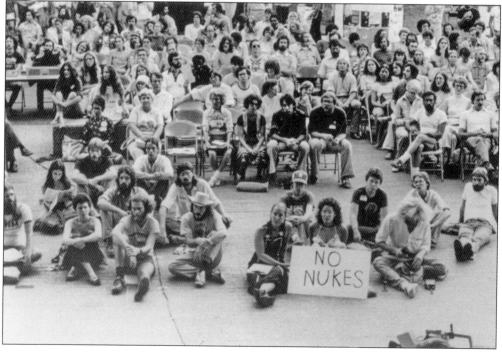

On Disability Awareness Day (May 1, 1991), administrators, students, and staff participate in a wheelchair tour of campus. From left to right are (first row) Jeff Burgin and Ron Burgin; (second row) Ed Dusch and Jane Bell. The Disability Resource Center fosters an inclusive campus climate and provides support for students needing special accommodation.

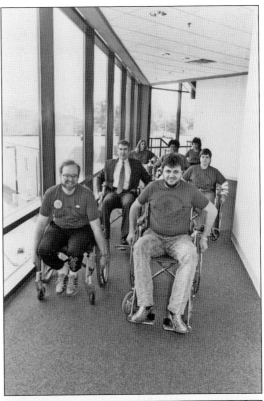

Louisville's world famous Kentucky Derby has inspired campus contests of all kinds. Turtles, tricycles, and beds have all competed for victory garlands. Here, Cardinal jockeys mount tricycles at a Pegasus Pedalathon at the Fairgrounds Motor Speedway in 1969.

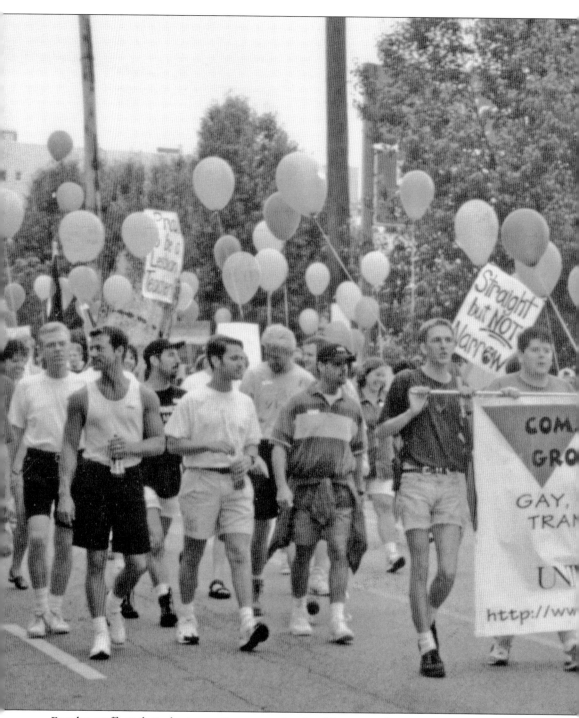

Faculty, staff, and students continue to strive for fairness and justice. Here, students and supporters walk for awareness in downtown Louisville during the June 29, 1997, March for Justice. CommonGround, begun in 1995, is a student organization that supports and promotes the welfare of gay, lesbian, bisexual, transgender, queer, questioning, and intersexual students and their allies. The LGBT Center was founded in 2007 and works to

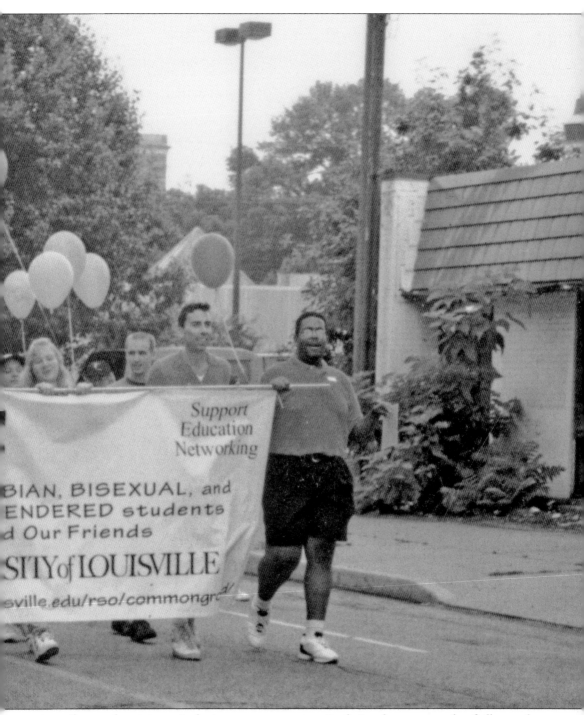

Support
Education
Networking

BIAN, BISEXUAL, and
ENDERED students
d Our Friends

SITY of LOUISVILLE

sville.edu/rso/commongr

strengthen and sustain an inclusive campus community that welcomes people of all sexual orientations, gender identities, and gender expressions through support, educational resources, and advocacy. In 2009, UofL became the first school in the country to endow a chair in LGBT studies. (Courtesy of David Williams.)

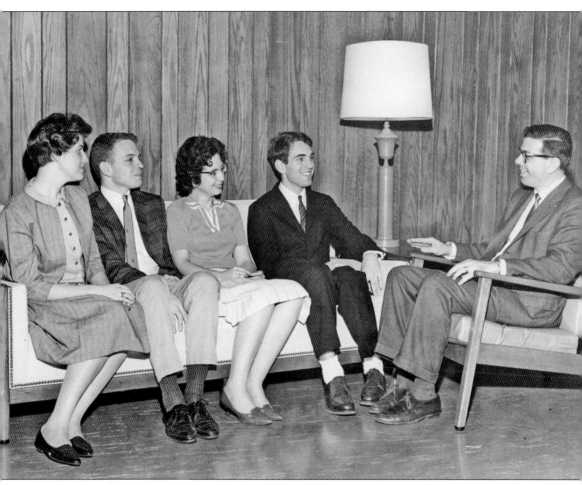

The General Electric College Bowl was a popular television quiz show broadcast in the 1950s and 1960s. Schools faced off each week for the opportunity to advance and face a new opponent, for up to five weeks. In the spring of 1963, UofL's foursome clobbered Kenyon College. In the second round, the University of Idaho fell to the University of Louisville's quick buzzer. Against Delaware University, the Cardinals posted the second highest score in the history of the College Bowl, 370 points. Alas, the final match went to Yeshiva University. The Louisville community rallied around the group and the local news media covered the matches extensively. Upon the team's return to Louisville, a crowd, including Gov. Bert Combs, was there to cheer on the students. The university also held a convocation in their honor. The group earned $13,000 in scholarship funds for the university. From left to right are team members Ann Groves, Frank Knull, Evelyn Feltner, and Giles Kotcher, along with coach Dr. Martin Stevens.

Eight

PLACES YOU MAY REMEMBER

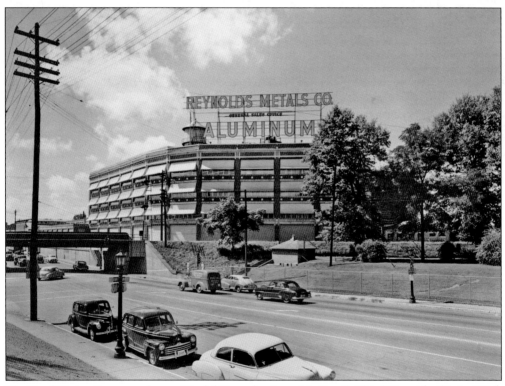

The Ford Motor Company began Model T production at its South Third Street facility in 1916. The automobiles rolled off the line until 1925. In 1940, the Reynolds Aluminum Company converted the building to offices, and later, Reynolds donated the site to the university. Music practice studios, a print shop, scientific collections, Potamological Institute, and Photographic Archives were located there. In 2001, the building was converted to condominiums.

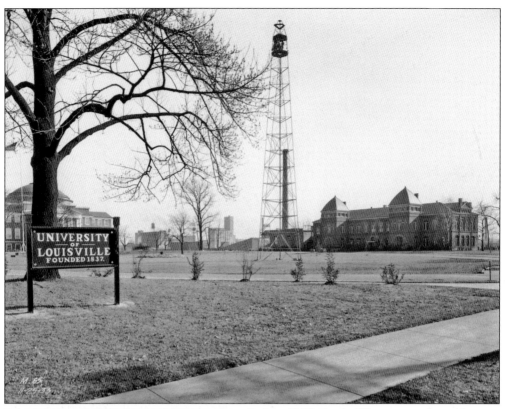

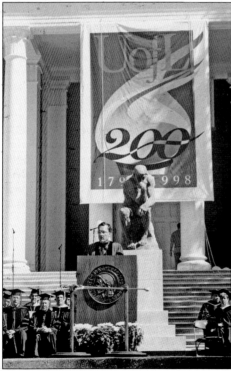

In late 1933, Louisvillians were alarmed by beacon lights piercing the night sky. The *Courier-Journal* explained that the US Coast and Geodetic Survey had erected five projection facilities around the city, including a 110-foot observation tower on the Belknap Campus oval, to triangulate the direction of true north. The sign at left above is a reminder that until 1948, the University of Louisville accepted 1837 as its founding date because a Louisville Medical Institute launched that year was simply renamed the Medical Department of the University of Louisville when the university was formed in 1846. Later, the university adopted 1798 as its founding date. Founders Day, on April 3, 1998, marked the date, 200 years earlier, when the charter for the old Jefferson Seminary was signed. At left, the 1998 university bicentennial celebration was already much anticipated based on the banner behind John W. Shumaker at his 1995 inaugural as the University of Louisville's 16th president.

The Rauch Memorial Planetarium was completed in 1962 and named for university trustee Dr. Joseph Rauch, a local civic leader and longtime rabbi of Temple Adath Israel. The dedication speaker described the planetarium as a dynamic educational tribute to Rauch, "a man who always had his feet firmly planted on the ground, but a man whose eyes were always on the stars." It was built at a cost of $125,000 (including equipment), seated 80 adults or 100 children, and was the first planetarium to be built in Kentucky utilizing the Spitz A-3P projection system. The last presentation in the original facility occurred on February 6, 1998, because it was slated for demolition to make way for a parking garage behind the J.B. Speed Art Museum. The university received $1.6 million to support the construction of a new planetarium. The Gheens Foundation pledged $1.1 million, with the city of Louisville and Jefferson County each committing $250,000. The new state-of-the-art facility was placed behind Strickler Hall, facing the School of Music near the College of Business. The Gheens Science Hall and Rauch Planetarium opened in 2001, providing programming for physics and astronomy classes, school presentations, and the community.

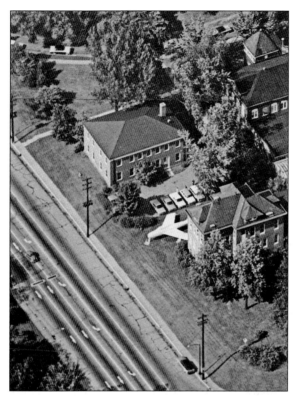

In 1956, Kentucky's Air National Guard donated an obsolete F-84 fighter jet to the UofL's Air Force ROTC unit. The aircraft was installed between McCandless and Patterson Halls, with the cockpit looking out upon Third Street. After some years, the plane was returned to the Kentucky Air National Guard and used for firefighter training.

Miller Hall opened in 1965 as a 308-bed men's dormitory, complete with a campus barbershop on the first floor. Longtime barber George Coone is pictured in 1976, smoking a pipe and staring out toward the dormitory's rear parking lot from the shop door. The shop closed in the late 1980s.

It is estimated that 100,000 Interstate 65 motorists per day sped past the double set of 10 concrete silos that sat adjacent to Belknap Campus until 2014. For more than 15 years, the 100-foot-high grain towers facing the roadway were emblazoned with lettering spelling out "University of Louisville," one of the earliest efforts of a massive campus beautification project. Locals remember the site for the unappealing smells spewing from the Ralston Purina facility, byproducts of processing cereal, oil, and other goods. The facility was responsible for a massive sewer explosion in 1981.

The pedestrian overpass, often called "the gerbil trail," was constructed in 1980 as a means for students to safely access campus from the east, bypassing the CSX (L&N) tracks that run north-south parallel to Floyd Street. On December 13, 1985—Friday the 13th—a crane loaded on a railcar struck the 23-foot-high walkway causing the concrete platform to buckle, warping the main girders, and mangling the metal mesh covering. The repairs cost $65,000 and took four months.

Located between Gottschalk and Gardiner Halls, Parrish Court honors distinguished sociology faculty member Charles H. Parrish Jr. In 1951, when the university's racially separate arm, Louisville Municipal College, was closed, Dr. Parrish was the only faculty member invited to teach at the newly integrated Belknap Campus. The outdoor sitting area was created in 1977, on the site of the Dean's Building, formerly called the Women's Building.

A volunteer, student-run radio station using the call letters WLCV ("Louisville Campus Radio") began in Stevenson Hall in 1968. (The station was called WXKE between 1969 and late 1975.) It never had a broadcast range that went beyond campus. The transient station had several homes, including a picture window on the east end of the frame Chemistry Annex (behind Gottschalk Hall), the first floor of the MITC, and, until the station closed in 2013, in the food court area of the SAC. At the same time, following a gift of thousands of classical music recordings from WHAS-FM and an early financial commitment from that station's owner, the university launched WUOL-FM, broadcasting public information and classical, jazz, and folk music for several decades before becoming a classical music and fine arts station in today's Louisville Public Media lineup.

In December 1936, the Florsheim Shoe Company's Fourth Street window display urged shoppers to "Boost UofL 'Cardinals' They're Going Places." Intermixed with the loafers and wingtips were action photographs of players and "the Caravan" team photograph. The store was located at the present-day Fourth Street Live entertainment complex.

Nine

FACES YOU MAY REMEMBER

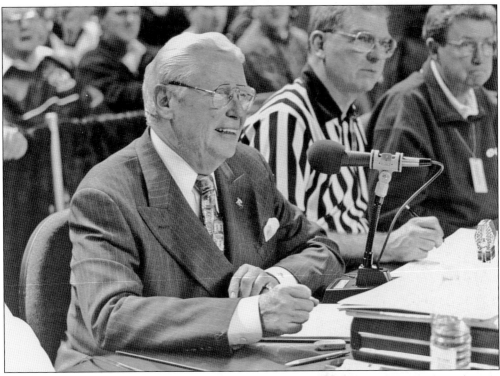

Veteran announcer John Tong began each game with "Good evening, ladies and gentlemen, and welcome to the Kentucky Fair and Exposition Center and world-famous Freedom Hall for the thrill and excitement of college basketball." Tong was the voice of the Cardinals for 40 years and announced football games in addition to men's basketball. He will be remembered for his dapper dress, unique player introductions, and the distinctive cadence of his signature phrases "steps called," "time is out on the floor," and "one minute remains." John Tong retired in 1999.

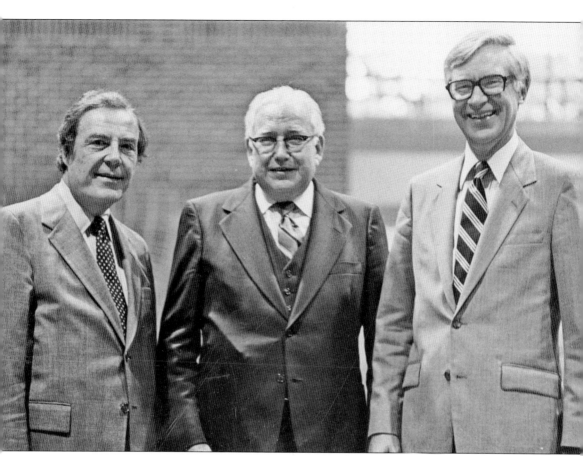

This triumvirate of University of Louisville presidents—(from left to right) James G. Miller, William F. Ekstrom, and Donald C. Swain—spanned 23 years of dramatic university growth and expansion in the last decades of the 20th century. Miller served from 1973 to 1980, Swain 1981 to 1995, and Ekstrom, as acting president, before and after Miller, 1972 to 1973 and 1980 to 1981. Each leader wrestled with the significant challenges that face a modern university presidency including satisfying a diverse constituency and providing adequate funding. The UofL presidency dates from 1846, when an existing medical school, new law school, and an intermittent liberal arts college were joined under the University of Louisville name.

Quarterback Johnny Unitas, No. 16
(pictured with teammate Otto Knop)
finished his college football career in
1954, completing 247 of 502 passes for
2,912 yards and 27 touchdowns. Unitas
was a standout on lackluster teams that
played home games on the baseball
diamond at Parkway Field. His is the
only retired jersey in Cardinal football
history. Unitas was drafted ninth by
his hometown Pittsburgh Steelers but
was cut soon after. Then, he worked
full-time and played with a semi-
professional team until he was picked
up by the Baltimore Colts and later set
a National Football League record with
47 consecutive game touchdown passes.
He was inducted into the NFL Hall of
Fame in 1979. Unitas Tower, the 11-story
student dormitory built in 1971, was
named in his honor.

The first crawfish boil dates to the early 1980s when the Adults on Campus Committee held the first all-you-can-eat buffet fundraiser consisting of crawfish, polish sausage, potatoes, corn-on-the-cob, onions, and red beans and rice. According to George Howe (left), director of the Red Barn, 100 people attended the feast held on the lawn of Threlkheld Hall. Today, 650 pounds of seafood is provided to 500 guests, with proceeds going to scholarships. Below, David Baugh prepares the smorgasbord. George Howe was the first director of student activities, starting in 1970, and was a major force in developing the Red Barn, ensuring a facility and programs for students. For more than 40 years, the Red Barn has hosted concerts, lectures, cookouts, Greek events, and much more. Howe has acted as host for most of those 40 years.

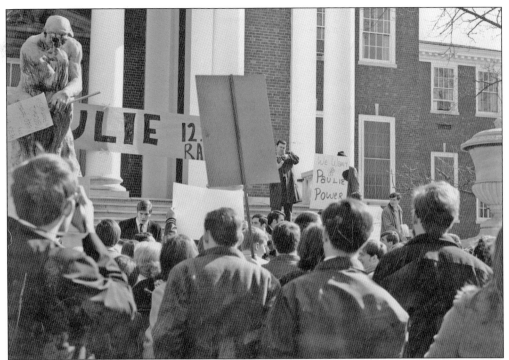

During the first decades after World War II, the football program was threatened with extinction on several occasions because it was deemed such a financial liability. In 1965, the faculty senate narrowly approved a proposal to abandon the sport (the motion was overridden by President Davidson). Four years later, another gridiron kerfuffle occurred when long-time coach Frank Camp retired and the university, over student objections, named the mercurial Lee Corso head coach instead of popular native Louisvillian assistant coach Paulie Miller. The 1907 team is pictured below.

Howard Schnellenberger grew up in Louisville, where he played football at Flaget High School. He was later a star player at the University of Kentucky. He became the head coach of the Louisville Cardinals in 1984 following head coaching positions with the Baltimore Colts and the Miami Hurricanes. After the Cardinals demolished the University of Alabama in the 1991 Fiesta Bowl (Louisville's first since 1958), Howard famously quipped that his program was "on a collision course with the national championship. The only variable is time." Schnellenberger took football from near extinction to winning records; in his last season, the average attendance was over capacity at 35,888 in old Cardinal Stadium.

The International Center began in 1949, a time when the United States' role in global security and economic and cultural affairs escalated. Initially housed in a downtown office, the center quickly moved to Belknap Campus, where it stimulated international exchanges, promoted foreign trade, welcomed visiting scholars and dignitaries from around the world, and helped the growing foreign student population feel at home. In 1970, with broad financial support from the community, the International Center built a home of its own behind the School of Law. In 1981, it was named for Romanian immigrant George Brodschi, the center's first executive director, who served from 1949 to 1978. Above, students in traditional dress attend a holiday reception at President Davidson's residence.

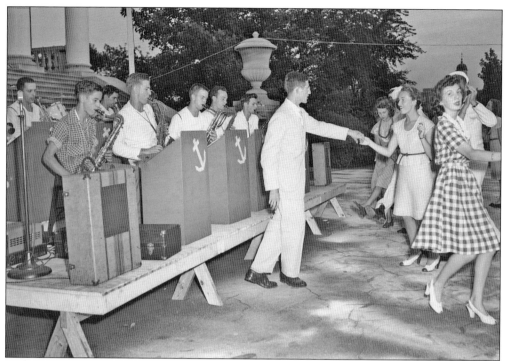

From the 1950s to the 1990s, Harry Bockman was everywhere. Enrolling at the university after distinguished service in World War II, he made his mark as a swimmer and track star. He then went to work in the registrar's office, where he became a familiar fixture at arena registration. Bockman was even more recognizable as the student ID "police" at sporting events and as a member of the line crew at football games. Bockman is pictured above in 1945 at a dance in front of the administration building and below, later, at registration.

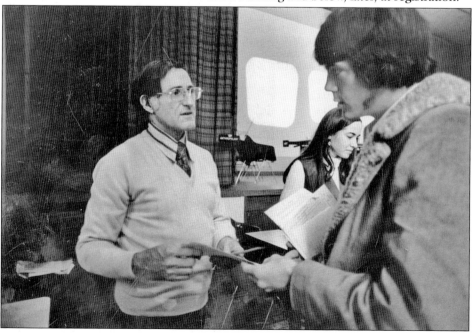

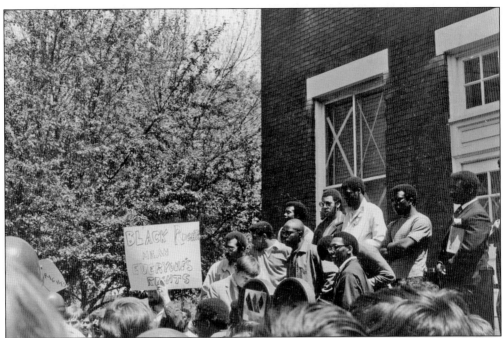

In 1969, student demonstrators, demanding black studies courses and programs, refused to leave the arts and sciences Dean's Building. Blaine Hudson, who was among the students arrested, was expelled from the university but, after a determined appeal, was readmitted the following spring. He went on to earn bachelor of science and master of education degrees at UofL and a doctorate from the University of Kentucky. In a fascinating twist, Dr. Hudson served seven years as the University of Louisville's arts and sciences dean until his premature death in 2013. He was an effective administrator, strong advocate for educational diversity, and an accomplished black history scholar. Hudson is pictured at right speaking at the dedication of Ekstrom Library's African American book collection.

Gordon Miller's home observatory, a modest frame building featuring a rounded roof that could be rolled back to reveal the night sky, was donated (along with a 12-inch telescope) and moved to campus in 1945. Mathematics professor and astronomy enthusiast Walter Lee Moore and Louisville Astronomical Society members spearheaded the effort to place it on an expanse of lawn between Ekstrom Library and the Speed Museum. The building was demolished in the mid-1950s and the equipment relocated to a sky-watching dome on the roof of the new Natural Science Building until 1978. At that point, the new Walter Lee Moore Observatory was unveiled on the 200-acre Horner Bird and Wildlife Sanctuary in Oldham County, which had been gifted to the university in 1960.

Renowned sculptor and alumnus Ed Hamilton immortalized Cardinal great Lenny Lyles with a bronze statue. Lyles, often called "the fastest man in football," grew up in Louisville and attended Central High School. The star running back, along with George Cain and Andy Walker, were the first African American athletes to play for coach Frank Camp. Lyles led the nation in rushing and was a standout in the victory over Drake University in the Sun Bowl on January 1, 1958. The win marked the first bowl appearance for UofL since closing Louisville Municipal College. Drafted 11th overall by the Baltimore Colts, Lyles played alongside former teammate and quarterback Johnny Unitas in the 1958 NFL championship game, nicknamed the "Greatest Game Ever Played." Hamilton's statue of Lenny Lyles was dedicated in 2000 and sits in Cardinal Park.

As the men's basketball coach, Peck Hickman (left) amassed 443 wins and also coached the golf team for almost 40 years. Hickman and assistant John Dromo recruited basketball All-Americans Butch Beard, Don Goldstein, John Turner, Charlie Tyra, and Westley "Wes" Unseld (below). Unseld compiled numerous records, still holds second place in points per season, and once scored 45 points in a single game—the most of any player in school history.

In February 2000, Pres. John Shumaker addressed the audience at a statewide salute to Muhammad Ali. The University of Louisville Muhammad Ali Institute for Peace and Justice was founded in 1997, building on the vision and lifelong work of Muhammad Ali by developing initiatives that support human dignity, foster responsible citizenship, further peace and justice, and address the impact of violence in local, state, national, and international arenas. The institute offers pertinent training, research, and hands-on assistance in support of creating lasting and effective strategies for peace.

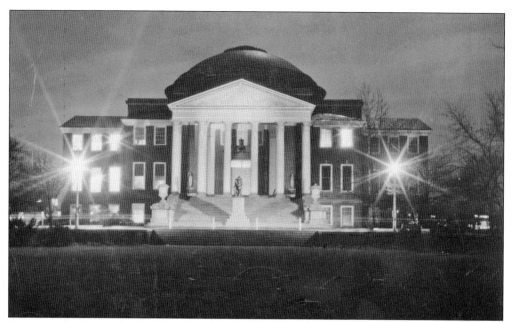

Unveiled on March 25, 1949, Auguste Rodin's first large-scale bronze cast of *The Thinker* was a gift to the University of Louisville from the city. Sources indicate this was the only "lost wax cast" version and likely the replica's creation was supervised by Rodin himself in Paris. Over the years, weather had turned *The Thinker* green, so starting in late 2011, conservators removed the corrosion and gave the figure a black-over-green patina similar to that on other versions. The mammoth sculpture continues to be a campus focal point with students, classes, and the community reveling in its beauty at the entrance of Grawemeyer Hall.

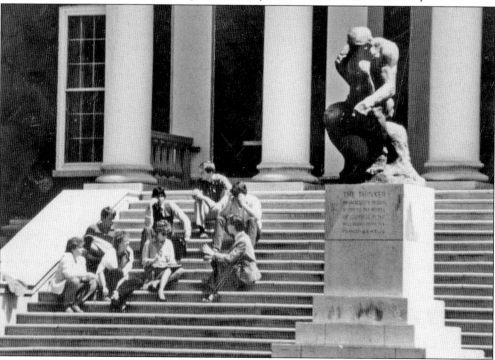

On March 30, 1967, extra chairs were set up in a futile effort to accommodate the overflow crowd that gathered to hear Martin Luther King Jr. at the Allen Courtroom at the Brandeis School of Law. Some of those who came strained to hear through windows open to the outside. The city was in the midst of a bitter fight to pass a local open housing ordinance, and King had come to encourage the demonstrators. While in town, he met with the national board of the Southern Christian Leadership Conference meeting at Zion Baptist Church where his brother was pastor, led a large protest rally at Memorial Auditorium where opponents to open housing had gathered, and consulted with his friend Muhammad Ali.

According to a *Courier-Journal* article recounting the occasion of Woody Strickler's inauguration as president, professor Bill Furnish was asked to present the new president a gift on behalf of the faculty. Furnish, ever the prankster, acquired a replica of Mount Rushmore and inserted a bust of Strickler just under Roosevelt's nose. The article recounted that Dr. Furnish unveiled it with a flourish, and the crowd loved it, but that Florence Strickler later confided she feared "for the dignity of the day when she found out that Bill Furnish was on the program." The actual present was a silver tea service. The Stricklers are pictured below.

Denny Crum came to the university in 1972 and spent his entire head coaching career at the University of Louisville. His overall record was 675-295, and he led the Cardinals to national championships in 1980 (defeating the University of California Los Angeles) and 1986 (defeating Duke). He was inducted into the Naismith Memorial Basketball Hall of Fame in 1994. On the court, he was known for his rolled-up program and always calm demeanor, earning him the nickname "Cool Hand Luke." Even in retirement, Crum continued to work for the university, serving as an ambassador assisting with fundraising efforts. The court at the KFC Yum! Center, home to men's and women's basketball, is named Denny Crum Court.

John Houchens came to the University of Louisville in 1949, working in the registrar's office and the Speed Scientific School. Upon his retirement as university registrar in 1971, Houchens was named university ritualist. When Houchens stepped down, political science professor Phil Laemmle took over the ritualist duties. Laemmle taught from 1972 to 2006 and was well known to students for his humor and engaging teaching style. Laemmle is pictured here.

The university mace was crafted by John Prangnell, assistant professor in fine arts. Weighing 16 pounds and measuring 43 inches long, the ceremonial baton is carried by the ritualist at all formal academic processions. Prangnell's vision resulted in a modern art piece rather than the more traditional styling of most college maces.

124

The Cardinal Bird has been a fixture since the 1950s. The Cardinal (Kentucky's state bird) began with a football helmet covered in chicken wire and papier-mâché with pipe cleaner eyelashes. A female companion, the Ladybird, appeared for some years. Later, the Cardinal Bird became a whole body costume with padded shell, big yellow hands and feet, and an exaggerated bird head with growling teeth and large beak. In 1995, the first mascot national championship was held and the University of Louisville's Aaron Flaker took the title. For the first few years playing at Papa John's Cardinal Stadium, a parachutist dressed as the Cardinal Bird descended into the stadium before lively crowds during pre-game festivities.

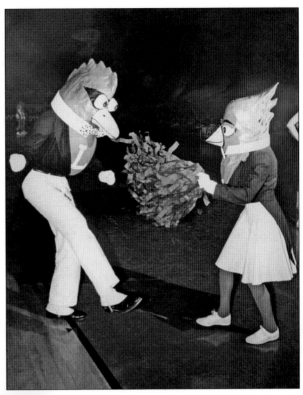

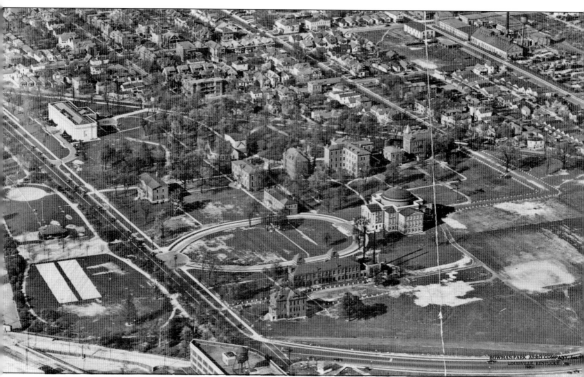

This photograph from the late 1920s shows that the era of the old reform school had fully given way to a new Belknap Campus. Third Street, Eastern Parkway, and the iconic 19th-century residence halls and workshops that belonged to the orphans and delinquents are there. The Reynolds Building and Stansbury Park (old Triangle Park) hint at the familiar. Change is in the air, though—a new Speed Museum and a new university administration building (Grawemeyer Hall) with its dramatic oval approach have reshaped the landscape. Belknap Campus was ripe for new creation, but most of what is there today was yet to come. This volume chronicles the dramatic transformations that still lay ahead when this picture was taken. The result is a campus some 90 years later that is barely recognizable from that shown here. What changes wait in the future? Will a visitor 90 years hence experience a similar anxious grappling for orientation, searching for defining landmarks that today are taken for granted?

ABOUT THE ARCHIVES AND SPECIAL COLLECTIONS

The University of Louisville Archives & Special Collections (ASC) collects, organizes, preserves, and makes available for research rare and unique primary and secondary source material, particularly relating to the history and cultural heritage of Louisville, Kentucky, and the surrounding region, as well as serving as the official memory of the university. The collections include significant holdings of documentary and fine arts photographs as well as rare books and manuscripts.

ASC serves as an internationally recognized repository of primary source materials, with a special commitment to documenting the life of our community. We have a dual mission to preserve these materials and to make them available to the public. All are welcome to visit our research room on the lower level of Ekstrom Library without charge. We also feature exhibits, which are also free and open to the public. We also host and teach classes, helping students hone their critical thinking skills by interacting with primary sources. Refer to the website of ASC at library.louisville.edu/archives.

We are continually adding to our Digital Collections. View historical images at digital.library.louisville.edu.

Questions, recollections, and archival donations can be referred to the authors at sherri.pawson@louisville.edu and tom.owen@louisville.edu.

DISCOVER THOUSANDS OF LOCAL HISTORY BOOKS
FEATURING MILLIONS OF VINTAGE IMAGES

Arcadia Publishing, the leading local history publisher in the United States, is committed to making history accessible and meaningful through publishing books that celebrate and preserve the heritage of America's people and places.

Find more books like this at
www.arcadiapublishing.com

Search for your hometown history, your old stomping grounds, and even your favorite sports team.